IMAGES
of America
BERKLEY

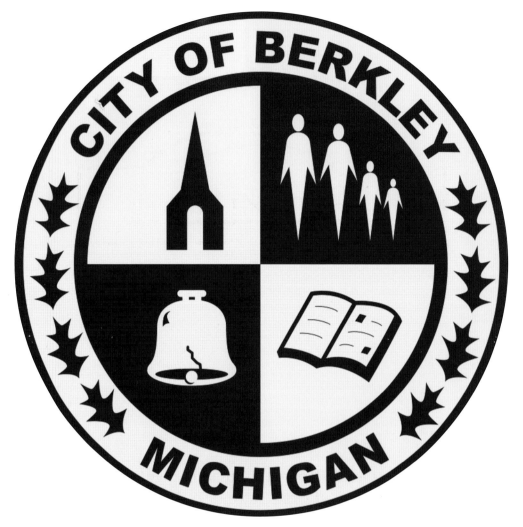

In 1960, the Veterans of Foreign Wars (VFW) held a contest to design a new flag for Berkley. Berkley High School senior Gary Ostendorf won, and his entry continues to serve as the city's emblem, appearing on city documents, signage, and the flag. The colors are satellite blue on white for space-age optimism. The sphere represents the world, while the oak leaves symbolize Oakland County. The church, book, liberty bell, and family stand for important aspects of Berkley life.

ON THE COVER: Members of the Berkley Fire Department stand next to their 1953 American LaFrance. Berkley City Hall housed the fire station and the police on the first floor. The second floor contained other city offices, including the first library. The small white house to the left of city hall contained the finance department, which was relocated to city hall in 1989, when police and fire operations were moved into the new Public Safety Building.

IMAGES
of America

BERKLEY

James Jeffrey Tong, Dr. Susan Richardson,
and Hon. Steve Baker

ARCADIA
PUBLISHING

Copyright © 2013 by James Jeffrey Tong, Dr. Susan Richardson, and Hon. Steve Baker
ISBN 978-0-7385-9975-5

Published by Arcadia Publishing
Charleston, South Carolina

Printed in the United States of America

Library of Congress Control Number: 2013931090

For all general information, please contact Arcadia Publishing:
Telephone 843-853-2070
Fax 843-853-0044
E-mail sales@arcadiapublishing.com
For customer service and orders:
Toll-Free 1-888-313-2665

Visit us on the Internet at www.arcadiapublishing.com

The authors dedicate this book to their family and friends for their tremendous love and support, especially (Jeff) Emily and James Vickey; (Sue) Mark, Emma, and Eric Richardson; and (Steve) Nicole Artanowicz, Suzy Marin, and Christine Baker.

CONTENTS

Acknowledgments 6

Introduction 7

1. Early Berkley:
 From the First Settlers to 1920 9

2. From Village to City:
 The 1920s and 1930s 21

3. The Boom Years:
 The 1940s and 1950s 41

4. Berkley Blossoms:
 From 1960 to the Present 59

5. School Days:
 Educating the Citizenry 75

6. Religious Life in Berkley:
 A Heritage of Spirituality 89

7. Berkley Celebrates:
 Parades and Events 101

8. Municipal Offices and Public Safety:
 Serving the Community 109

9. Roseland Park Cemetery:
 Honoring the Departed 119

About the Authors 127

ACKNOWLEDGMENTS

The authors thank the large number of people who shared their time, photographs, knowledge, and enthusiasm with us. This book would not have been possible without their support and the patience of our families.

We most especially recognize the major role played by three women who have worked for years to collect and preserve Berkley's history. The late Shirley McLellan was the pioneer in preserving and writing about our past. As the Berkley reporter for the *Daily Tribune* for many years, she wrote extensively about our history. Much of the museum's collection was due to her work as the first chairperson of the Berkley Historical Committee.

Carol Ring was the first vice chairperson of the Berkley Historical Committee and later replaced Shirley as chair; she continues to serve on the committee. Maybelle Fraser was Berkley's first female mayor and a major researcher into our past. These two women have devoted years to collecting and sharing information about the city's past, and they spent hours with us looking at photographs and answering our questions. They have been extremely patient and gracious, and we sincerely thank them.

In addition, Mary Hughes, former Berkley city clerk, compiled a brief history of the city in a booklet distributed during the celebration of Berkley's 75th anniversary in 2007. Her collection of photographs and historical records served as inspiration for this project.

We also thank the current and recent members of the Berkley Historical Committee for their dedication and countless hours of volunteering to preserving Berkley history: Bill Ackerman, Elaine Andrade, Karen Brocklehurst, Shirley Hansen, Janice Lovchuk, Waneda Mathis, Mary-Catherine Mueller, Danielle Ozanich, Carol Ring, and Neil Ring.

Finally, we are grateful for the following who shared information and photographs with us: J.S. Brooks, Mike Cotroneio, Robert Cook, Daniel Darga, Jerry Durst, Pat Fox, Yvonne Fuller, Heather Hamlin, Shirley Hansen, Judy Harnois, Harry Hartfield, Rob Henry, Mark Keegan, William Krieger, Mike Kurta, Nancy Line, Kyle Matthews, R. Murphy, Cheryl Printz, Robert Roberts, Donna Sayers, Kathy Schmeling, Tim Toggweiler, Marcia Tong, and Celia Morse, director of the Berkley Public Library, and her staff. Please forgive us for any omissions, as those would be purely unintentional.

Unless otherwise noted, photographs are courtesy of the Berkley Historical Museum.

INTRODUCTION

When settlers began arriving in what would become Michigan, the land where Berkley now stands was not considered suitable for habitation. The first government maps show the entire area to be one big swamp with a huge forest of maple, oak, elm, beech, and pine. The trees were so thick that the sun could not even reach the ground to dry the land, and the many brooks flowing from underground springs further contributed to the watery environment.

Even the Native Americans avoided the area. The soil was too thick and gummy for growing crops, and the deep forest prevented the growth of edible plants, which in turn reduced the amount of game for hunting.

A survey of the land ordered by the US government after the War of 1812 concluded that the swamp could not be drained, and even if it could be, the land was so poor as to discourage habitation. Settlers in Detroit avoided the area and used rivers and lakes to go around it.

However, Territorial Governor Lewis Cass decided to check out the area himself in 1817 and told Congress that the land should be sold. In 1818, the government started selling land in what would become Berkley for $1.25 an acre. Settlers from the East, lured by the promise of cheap land, began to arrive.

These early arrivals started draining swamps and clearing the land. They had to contend with malaria, cholera, and ague. These thrifty, industrious, and religious settlers included Lyman Blackmon, who gave a half acre of his land to be used as a school in 1834 (it was used until 1901).

By 1832, there was regular travel between Detroit and Pontiac that passed through Berkley. The trail people used is today known as Woodward Avenue, a major artery in the Detroit metropolitan area, but in the early 19th century the road was so muddy that coaches were constantly getting stuck and had to be pushed out.

In 1834, the Territorial Legislature of Michigan decided it had to do something to improve transportation because farmers needed more dependable means of getting their crops to market in Detroit. The legislature authorized the construction of the Detroit-Pontiac Railroad. This early rail line was primitive and even dangerous, as cinders from the engines often caused fires. But it was progress, and more and more people arrived in Berkley.

Among those who came was John Benjamin, who founded the first industry in Berkley. He began making excellent grain cradles that were sold all over the East and as far west as St. Louis. Still, settlement was painfully slow. Berkley consisted of a few scattered farms with no stores or services. Farmers went into Royal Oak or Birmingham for their daily needs.

Life changed in the early 1900s with the appearance of the automobile. When Henry Ford began producing his "Tin Lizzies" in nearby Highland Park, the effects were felt in Berkley. The high wages for Ford employees attracted settlers from all over America, and many found their way to Berkley. By 1915, many early Berkley residents worked in the Highland Park factory.

World War I forced industry to expand rapidly and caused a population explosion. Land was cheap, and the Detroit Urban Railroad allowed quick access to jobs in the factories. Houses were rapidly being built even though there were still no sewers, water supply, or electricity.

Berkley was still part of Royal Oak Township, but many citizens began to think about forming a government and becoming a village; however, there was no unanimity about the shape the new municipality would take. Two factions emerged: one desiring a highly developed town with a large shopping district on Woodward Avenue, while the other a smaller, working-class community. The conflict resulted in a race to the Oakland County Courthouse in Pontiac. The small-town proponents camped out overnight and beat their rivals to file the necessary paperwork, thus sealing Berkley's current identity. Berkley officially became a village on April 6, 1923.

The village rapidly established a new water system, police and fire departments, and the first village office, as well as improved streets. In 1926, the Odd Fellows organized the first Berkley Days festival to commemorate the extension of Coolidge Highway. Two years later, the new village hall and police and fire building were dedicated. Also, by then, the village had two doctors and two drugstores.

The Great Depression brought an abrupt halt to this growth. Factories closed, and much of the population lost their jobs. Land prices plummeted, and property taxes brought in less and less money needed to operate the government. The Village of Berkley ended up owning 80 percent of the 6,000 pieces of property due to foreclosures. Streetlights were turned off, and employees were laid off.

Despite such problems, there was a movement in the early 1930s to turn Berkley into a city. The main reason: money. If Berkley became a city, it would not have to pay taxes to Royal Oak Township. Also, as a city Berkley could avoid being annexed by the City of Royal Oak and therefore could control its own affairs. On May 23, 1932, voters went to the polls and made Berkley a city. It now had a mayor, a council consisting of five members, a clerk, treasurer, judge, constable, and assessor.

World War II propelled the country and Berkley out of the Great Depression. During the 1940s, the city rapidly grew. In fact, growth was so rapid that Berkley had to hire the first city manager to handle the administration of the city's business.

Housing construction boomed, and residents poured in. By the early 1950s, there were few empty lots left. The schools that were closed during the Depression were reopened, and new schools, including Hamilton (now Rogers) and Our Lady of LaSalette, were opened. In 1964, the library finally got a new building, and the police and fire departments moved into a new Public Safety Building in 1989. Berkley's first website was created in 2003. Today, Berkley's 2.6 square miles are home to approximately 15,000 citizens.

Berkley's residents have been proud of their history and have sought to preserve its past. As part of the nation's bicentennial, the Berkley Historical Committee was established. The committee's collection of materials and artifacts rapidly increased with donations from Berkley's citizens. In 1991, the Berkley Historical Museum was opened in the old Fire Hall. This book represents yet another phase in the ongoing effort to preserve and promote the city's diverse history.

One

EARLY BERKLEY
FROM THE FIRST SETTLERS TO 1920

Early writer Shirley McClain, in *Briefly Berkley*, describes Berkley's first settlers as "thrifty, industrious and religious people who believed firmly in hard work, and going to church." Indeed, these were good qualities to confront the difficulties they faced in taming the inhospitable territory. Swampy and infertile land, miles to the nearest store, and often impassable trails made life very difficult; however, the fact that conditions in the East were even more forbidding after the War of 1812 lured the first hardy souls to make the trek.

Michigan's territorial governor, Lewis Cass, ordered the extension of the road from Detroit to Pontiac to facilitate travel. That decision paved the way for Berkley's emergence.

The names of early settlers live on in Berkley's history. These pioneering families cleared the land and literally built Berkley. Lymon Blackmon arrived with his family in 1830 and bought land between what is now Catalpa Drive and Twelve Mile Road. He donated a portion of his property for Berkley's first school.

The Cromie family purchased land from the Blackmon family and started Berkley's first dairy. A portion of the Cromie property is where Roseland Cemetery stands today.

Elisha Bergen bought land near what is now Eleven Mile Road. One night, while returning from Royal Oak, he was almost killed by wolves.

Hamlet and Martha Harris built a farm near today's Catalpa Drive. Hamlet was a Native American and was listed as a "free person of color" on official records. Their farmhouse still stands on Catalpa, and today it is a multiple-unit building.

The Bolger family's farm was in southeast Berkley. Robert Bolger became one of the first Berkley boys to fight in the Civil War.

Berkley remained an area of scattered farms until the railroad and interurban system were built along Woodward Avenue. When Henry Ford built his factory in Highland Park, factory jobs exploded, especially with the advent of World War I. Because of the related need for more housing, the farms were quickly sold to developers, and by the time World War I ended there were only two farms left in all of Berkley.

Map — Berkley 1892 Original Farms

| Hiram Ellwood | Bernhart Rusch 77 Acres | Mrs. Maria Pittenger 77 Acres | Taylor's Woods 77 Acres | John Benjamin 162.5 Acres |

12 Mile Road

| 154 Acres | William Salts 100 Acres | Ends 60 Acres | Lyman Blackman 104 Acres | Coolidge Highway | Robert Ferguson 55Acres | A. Young | O. Schilling 35 Acres / Matthew Harris / Hamlet Harris | Woodward Avenue → | San Med 157 |

Catalpa

| A.McClelland 80 Acres | Robert Brown 156 Acres | John Stevens 78 Acres | Joseph H. Quick 60 Acres | Hamlet Harris 57 Acres | Charles VanValkenburg 78 Acres |
| | | | Michael O'Flaherty 60 Acres | Hamlet Harris 20 Acres | Fred Remole 47 Acres | Frank Briggs 80 Acre |

Berkley 1892 Original Farms

The locations of Berkley's original farms are plotted on this 1892 map. The owners' names echo through Berkley's early history. Most of these early settlers paid $1.25 an acre for their farms.

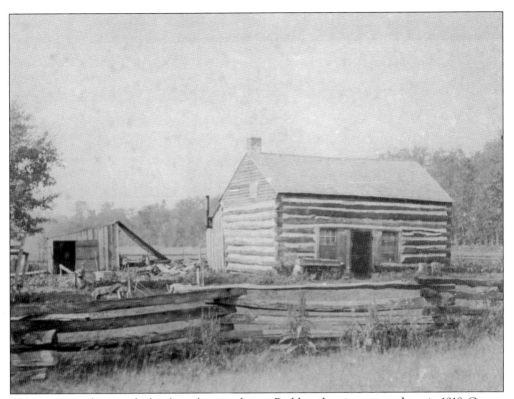

The Pittenger cabin was the last log cabin standing in Berkley when it was torn down in 1918. George Hoagland purchased the land for $400 in the 1830s. The cabin had two bedrooms on the second floor and stood where the entrance to Rite Aid is today at Twelve Mile and Wakefield Roads.

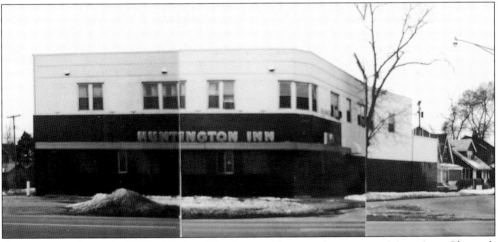

Sometime in the early 1820s, Mother Handsome, whose real name was Mary Ann Chappel, established a log cabin inn for weary travelers making the long trek from Detroit to Pontiac. At that time, travel was very difficult because the forerunner of Woodward Avenue was a "corduroy road" constructed with logs. Travel was further impeded by the cranberry bogs running from Six Mile to Eleven Mile Roads, which caused the logs to rot. In 1829, Henry Stephens bought the inn and named it the Red Tavern. From 1930 to 1975, the Huntington Inn was a popular restaurant and bar. Blarney Stone Pub now stands on this location.

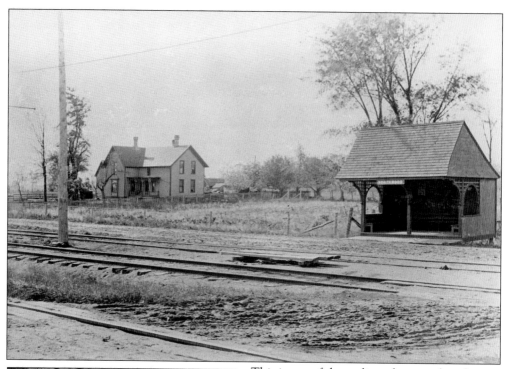

This is one of the earliest photographs taken in Berkley, showing the corner of Twelve Mile Road and Woodward Avenue in 1902. The farmhouse on the left became Cotter's Tavern. The sign on the woodshed reads, "Northbound," because people waited here for the Detroit interurban train. They would wear boots to the station and leave them until they returned. There is no mention of footwear ever being stolen.

This very early undated photograph depicts the Cromie Dairy Farm on Twelve Mile Road. It was also known as the Northwood Dairy Farm. The building has been added onto many times and is now the Sawyer-Fuller Funeral Home. The original stairs to the second floor are still in use. Robert Cromie died fairly young, and Sara Cromie sold part of the property. She kept five lots, one for each child. The house at 2173 Rosemont Road is one of them.

The Lucas-Brown farmhouse dates from the 1860s and was built by Robert Brown. When Catalpa Drive was constructed in the 1890s, the house was in the way and had to be moved. It was cut in half and moved to Eleven Mile Road. The Brown family lived in one half and a tenant farmer in the other. The building occupied by the tenant farmer burned down during a New Year's Eve party. The photograph above is the building that still stands on Eleven Mile and Tyler Avenue. The image below is the original structure before it was split in two.

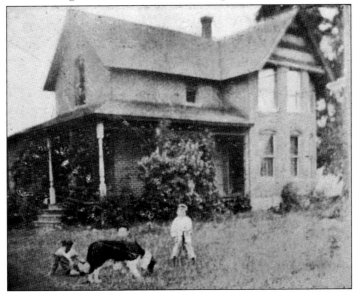

The Ellwood family arrived in Berkley in 1831 and built a homestead in 1845. It stood on the north side of Twelve Mile Road on the corner of Thomas Avenue. The family owned two farms, one on each side on Twelve Mile, stretching from Webster Avenue to Catalpa Drive. This home stood next to the A&W parking lot until it was torn down in the 1990s. Ellwood Avenue is named for the family.

This home was originally owned by Florene O'Dell and still stands at Wakefield and Wiltshire Roads, although it looks very different today. It is right across from Berkley Community Church. For many years, the church owned the home and allowed people who needed assistance to live there.

In 1830, Lymon Blackmon bought two 80-acre farms. This c. 1910 photograph shows his apple orchard that stood at what is now the intersection of Coolidge Highway and Beverly Avenue. He cut a lane in front of his home and named it Blackmon Lane. It was later renamed Monnier Road and then Coolidge Highway. The Blackmon family later sold the land to the Fons family.

This house was originally built as a dairy farm on what is now Greenfield Road. The house still stands and is notable for the flagstone basement, which was fairly common in farmhouses of the 1860s. The problem with the dairy farm was that it had no water, so the owner had to drive his cattle across the street every day to his brother's farm.

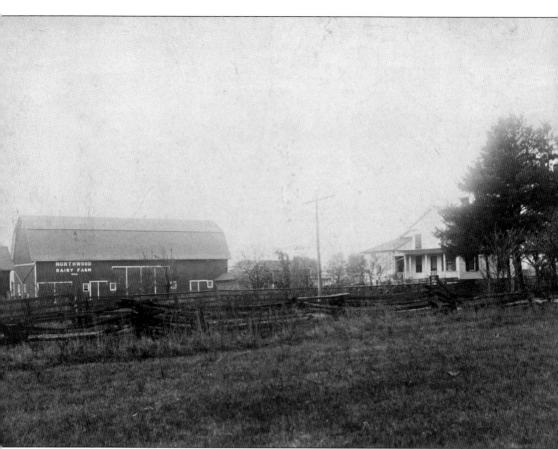

It is difficult to believe that less than 100 years ago, Berkley looked like this. The community was mostly farms and orchards during the early years of the 20th century. This photograph shows the home and barn of the Northwood Dairy Farm on Twelve Mile Road just west of Woodward Avenue. (Courtesy of Yvonne Fuller.)

Joseph Wilcox built his home on Sunnyknoll Avenue just west of Coolidge Highway in 1919. He was the first person in what became Berkley to receive a permit to build a home. There were no address numbers in Berkley until 1924, when this house became the first building to have an address.

Like so many other early farmhouses in Berkley, this one was moved. Originally on the south side of Catalpa Drive, today it stands on the north side and has been divided into rental units. It was built by Hamlet Harris, who arrived in Berkley in the 1850s. Hamlet was believed to be a Native American and is listed as a "free person of color" in the census records.

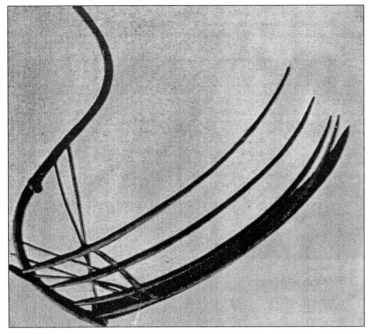

This is the Benjamin Muley Grain Cradle. John Benjamin arrived in Berkley in 1830 and bought 160 acres of land. Today most of that site is Roseland Park Cemetery. There, he invented this grain cradle, which was sold all over the country as far west as the Dakotas. The cradles replaced scythes in harvesting grain and were considered to be a major aid for farmers. They were eventually replaced by mechanical grain harvesters.

Berkley residents bemoan the destruction of many of the city's historic treasures. None is probably missed more than Cotter's Tavern, which stood on Woodward Avenue south of Twelve Mile Road for decades. The building was originally the Schilling farmhouse. The Cotter family later bought it and turned it into a tavern to make money during the Depression. It was torn down in 1967.

18

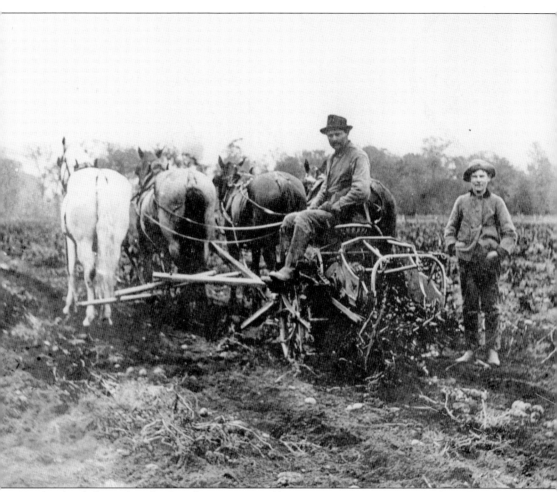

It is hard to believe that this bucolic scene is Berkley just 100 years ago. Here, Robert (left) and Elmer Cromie till the family farm just off what is now Twelve Mile Road. Three horses are pulling the tiller through what looks like a cornfield. Most of the yield was sent to Detroit to feed the urban population. (Courtesy of Maybelle Fraser.)

Sara J. Cromie poses here for a very formal portrait. The Cromie family arrived in Berkley in 1877 and purchased 53 acres of the Blackmon farm. They sold the land in 1916 to a developer to build a subdivision. (Courtesy of Yvonne Fuller.)

In 1837, Lymon Blackmon built his farmhouse in Berkley. He was one of Berkley's first settlers, and he donated his potato patch where the first school was built. There were no street addresses in Berkley until 1924, when this building was given the address of 3082 Coolidge Highway. Coolidge was first known as Blackmon Lane and then Monnier Road. The Fons family later bought this home, which was torn down in 1983.

Two

FROM VILLAGE TO CITY
THE 1920S AND 1930S

Berkley's first historian, Shirley M. McLellan, writes about this period in Berkley's history: "Life was not dull. There were quilting parties, church socials, barn raisings, skating and coasting parties at the schoolhouse, strawberry socials, berry picking and even a shooting club which met in Royal Oak."

Henry Ford and World War I altered this rural way of life. The opening of the Ford factory in nearby Highland Park and Berkley's position on the Detroit United Railway Line (DUR) attracted workers from all over America. The farmers, who owned most of the land, began to sell to developers, who divided the land into plots 40 to 50 feet wide and 60 to 100 feet deep. The start of World War I and the resulting increase in factory jobs in the Detroit area fostered a population boom in Berkley.

During this time, Berkley was still part of Royal Oak Township. As the population grew, the residents desired to form their own government to stave off annexation by the City of Royal Oak; however, the movement to become a village was not without controversy. Two factions with different concepts jockeyed to file paperwork at the county courthouse in Pontiac. The group desiring a small, working-class community camped out overnight and beat their rivals. On April 6, 1923, Berkley became a village following a vote of 360 to 165.

Growth was rapid in the 1920s. Most major Christian denominations established churches. Angell and Pattengill Schools opened. The first doctors opened practices, and stores serving every need emerged. Water lines were constructed, and streets were paved. The future seemed bright. Yet, when the Great Depression hit in 1929, Berkley was not spared. Newspapers estimated that 90 percent of the residents lost their jobs. The village's population declined by 400, and taxes dropped by 90 percent.

Most of the residents and the village government had kept their money in the Berkley State Bank. When it collapsed in 1932, all lost their money. The city was broke.

In May 1932, Berkley's residents voted to become a city to reduce its tax burden. Charles Williams became the first mayor, and the city waited and hoped for better times.

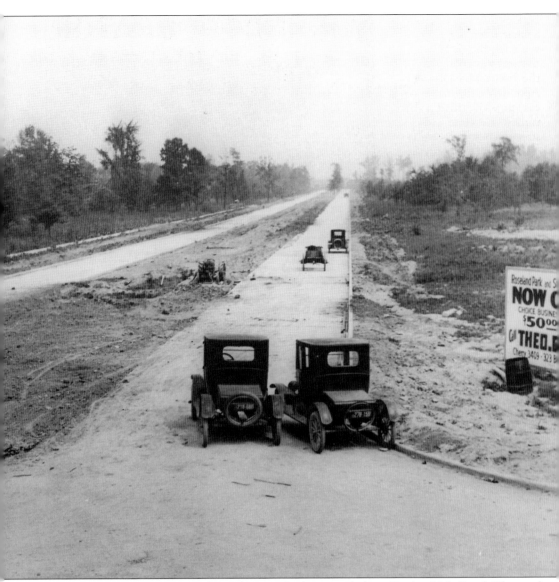

Coolidge Highway is seen in the early 1920s looking south from Twelve Mile Road. The road is not paved yet, so those Model Ts are lucky that the surface is dry and not swampy as it often was. Notice that the sign on the side of the street advertises property for sale, land that is now Roseland Park Cemetery. Early maps of Berkley indicate that Coolidge was slated to have houses on both sides. Along with a lot, a buyer could get either twelve chickens or a tent.

Berkley did not even have a name when this map was published in 1921; the area was known as the Twelve Mile District. Admittedly, the map is not easy to read. Still, it is the earliest one found with street names, and some of the subsequent changes are fascinating. Some street name differences include Twelve Mile (then Oakwood Avenue), Coolidge Highway (Monnier Road), Mortenson Boulevard (Second), and Henley Avenue (Third). Notice how much larger Roseland Park Cemetery was then. (Courtesy of Maybelle Fraser.)

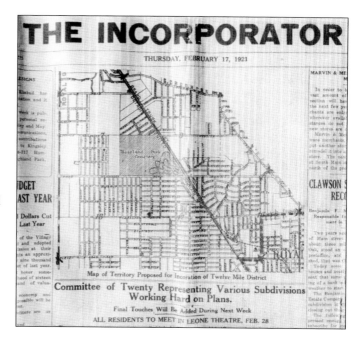

THE INCORPORATOR

THURSDAY, FEBRUARY 17, 1921

Map of Territory Proposed for Incoration of Twelve Mile District

Committee of Twenty Representing Various Subdivisions Working Hard on Plans.

Final Touches Will Be Added During Next Week

ALL RESIDENTS TO MEET IN LEONE THEATRE, FEB. 28

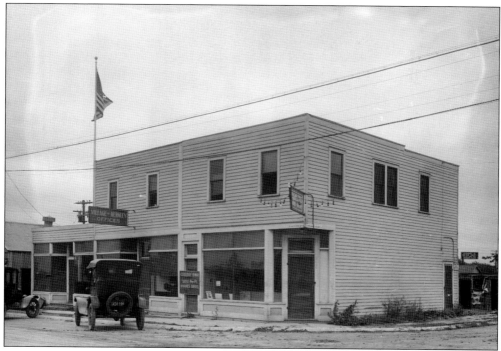

The flag flies proudly above the Village of Berkley offices on Twelve Mile Road sometime before 1920. The offices were moved when the building was found to be unsafe. (Courtesy of the Walter P. Reuther Library Archives.)

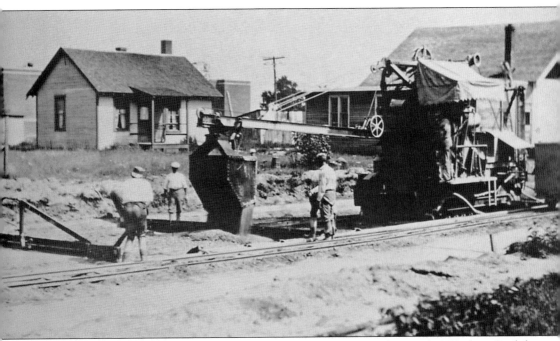

Pictured here, Coolidge Highway at Dorothea Road is being paved around 1927 when Coolidge was still named Monnier Road. The paving company was becoming very modern and moved the heavy equipment on rail lines. The house in the background is typical of the first homes in Berkley, consisting of two rooms. Owners typically built their houses at the back of the lot with the aim of later turning the structure into a garage and building a new house toward the front. The brick building (with a white line near the top) behind the house is Berkley School. Constructed in 1919, it was the first building in Berkley to be electrified.

This is the southwest corner of Woodward Avenue and Twelve Mile Road (Oakwood Avenue at the time) around 1929. An early gas station can be seen. To the left is the Shilling farmhouse, which later became Cotter's Tavern, a popular gathering place. There are two sets of tracks in the road, one for a train and the other for the interurban transit system. The tracks became the median for Woodward; at the time of the photograph, the road was only 16 feet wide, but today it is a bustling eight-lane divided thoroughfare.

Twelve Mile Road was named Oakwood Avenue in the early 1920s. The brick building in the foreground, on the corner of Oakwood and Griffith Avenues, soon housed Nellie Davis Drugstore. For many years, it was the only drugstore in the city. Doctor and dental offices occupied the second floor. Today, the building houses the gift store Catching Fireflies. (Courtesy of the Walter P. Reuther Library Archives.)

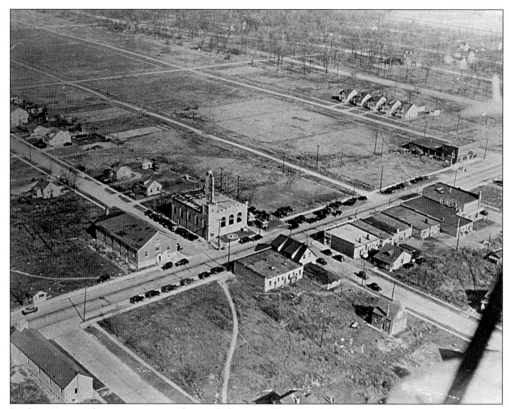

In the 1930s, real estate agents took aerial photographs of Berkley to use in sales promotions. This image looks north toward Twelve Mile Road between Tyler and Griffith Avenues. The amount of empty space is notable. Most homes were close to Twelve Mile, Coolidge Highway, or Woodward Avenue. Some of Berkley's most noteworthy buildings were already in place. On the north side of Twelve Mile stands the Christian Alliance Church (right) and the Odd Fellows Hall (left).

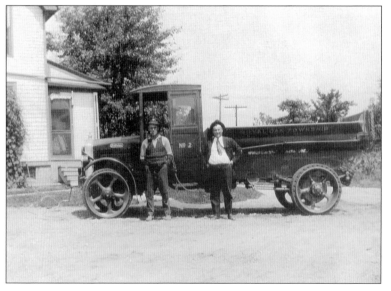

Herbert (left) and Elmer Cromie stand in front of the first Berkley fire truck around 1922 when Berkley was not yet even a village. The building on the left is the Cromie farmhouse, which is now part of the Sawyer-Fuller Funeral Home. The address then was 2122 Oakwood Avenue, but today it is 2125 Twelve Mile Road.

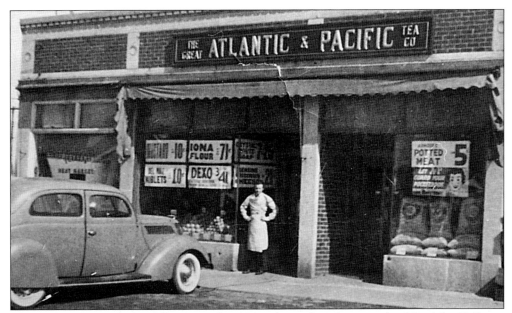

The Atlantic and Pacific Tea Company (A&P) was located on the east side of Coolidge Highway between Dorothea Road and Catalpa Drive. Shoppers appreciated the personalized service, as employees would greet them upon their arrival and gather and bag the items on their shopping lists. The A&P later moved to a bigger building on Twelve Mile Road and then to an even larger one on Eleven Mile Road. The latter building now houses a dialysis center.

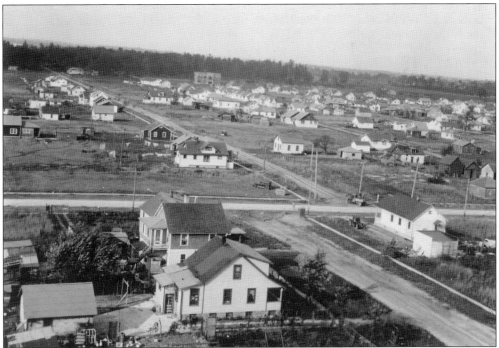

This photograph was taken from atop the old water tower, located on Bacon Avenue just south of Twelve Mile Road, on the grounds of the Berkley Public Works facility. In the far background can be seen Pattengill Elementary School, built in 1925.

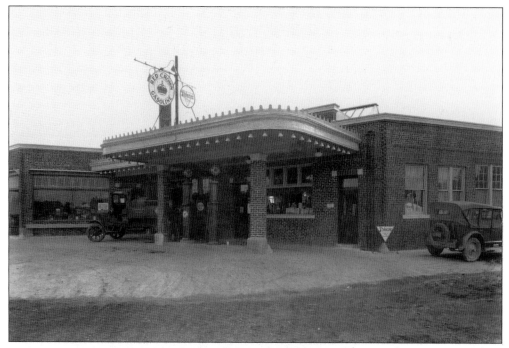

This is a close-up view of the Vinsetta Garage. The building is replete with gingerbread details, and signage is everywhere. Notice the 1920s cars parked in front. (Courtesy of Mike Kurta.)

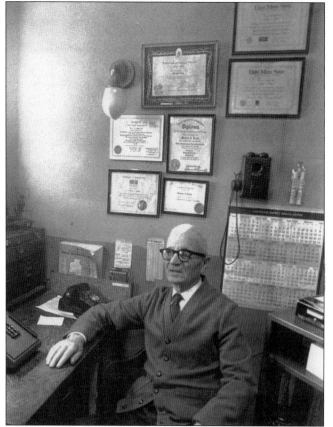

Mike Kurta Sr., who built the Vinsetta Garage, was 82 when this photograph was taken in 1970. The family lived in an adjoining apartment. The garage was actually named after two real estate developers Kurta knew named Vinton and Bassett. He combined the names and added an *a*. (Courtesy of Mike Kurta.)

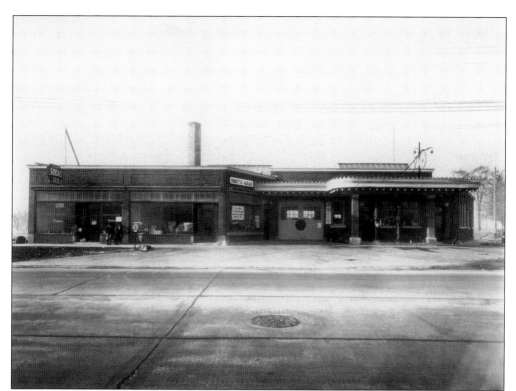

In 1919, when the Vinsetta Garage opened, steam trains still ran in front of it on Woodward Avenue, and no one foresaw that the building would stand there for 91 years. This is the second garage, constructed in 1925. The garage rented out the building attached on the left. It was first a drugstore and later a real estate office, a television repair shop, an antique store, and a dog grooming business. (Courtesy of Mike Kurta.)

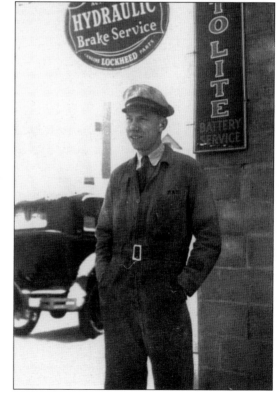

Ray Seamann stands outside the Vinsetta Garage in the 1920s. Ray worked at Vinsetta for many years until he started his own business, Seamann's Auto Mecca, on Coolidge Highway. (Courtesy of Mike Kurta.)

WHO'S WHO
In Next Monday's Election!

There are a few questions that enter the minds of voters at election time, and to satisfy the demand for information on these matters we offer herewith the results of our investigations. We do not hesitate to offer recommendations when facts merit them.

Several candidates are endorsed because they have the requisite qualifications. Others are turned down because they are affiliated with political tricksters whom the public cannot and will not trust.

If the voters elect the candidates herewith recommended we will have a set of officials who will give the village a genuine business administration.

OLIVER C. SWORDS, Candidate for President—
White, Gentile, Protestant, native born. His record as Village Commissioner warrants his election to the presidency. Recommended.

JOSEPH H. HERON, Candidate for President—
White, Gentile, foreign born. Not recommended.

WALTER G. BAKER, Candidate for Village Clerk—
White, Gentile, Protestant, native born. Village Clerk for past two years. Record satisfactory. Recommended.

MRS. PEARL HUNTT, Candidate for Village Clerk—
White, Gentile, Protestant, native born. Qualified but not recommended.

H. ISABELLE FRASER, Candidate for Village Treasurer—
White, Gentile, Protestant, native born. Present Village Treasurer; excellent record, eminently qualified. Recommended.

CHAS. P. UNDERWOOD, Candidate for Village Treasurer—
White, Gentile, Protestant, native born. Not recommended.

RUSSELL G. SMITH, Candidate for Commissioner—
White, Gentile, Protestant, native born. Clean, honest and efficient. A successful business man whom we are glad to recommend.

HENRY C. DALEY, Candidate for Commissioner—
White, Gentile, Protestant, native born. Frank, fearless and honest. Fully qualified. Recommended.

FRANKLIN L. LORD, Candidate for Commissioner—
White, Gentile, Protestant, native born. Fearless champion of civic reforms. Recommended.

JAS. D. COX, Candidate for Commissioner—
White, Gentile, Roman Catholic, native born. Not qualified. Not recommended.

CARSON DURHAM, Candidate for Commissioner—
White, Gentile, Protestant, native born. Has unsatisfactory record as Commissioner. Not recommended.

WILLIAM T. DUNCAN, Candidate for Commissioner—
White, Gentile, Protestant, foreign born. Poorly qualified. Not recommended.

THINK THIS OVER AND VOTE!

Election Monday, April 4th

In the 1920s, elections for Berkley officials were hotly contested. A group handed out this list of candidates with their recommendations. It is shocking to see that only native-born, white Protestants were endorsed. A group affiliated with the Ku Klux Klan probably issued this flyer. The Klan was very active in Berkley during this time and held a parade on November 3, 1926. (Courtesy of Maybelle Fraser.)

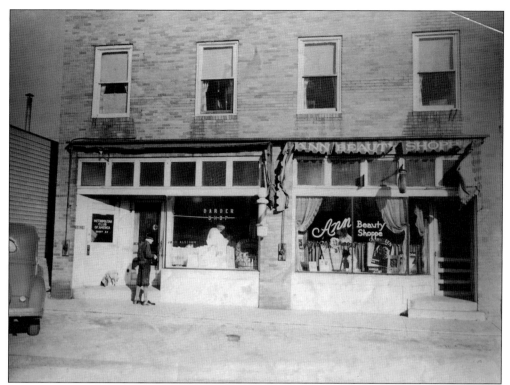

The year is 1937, and the street is Coolidge Highway. The corner of Bessinger's Market can be seen on the far left. Notice the man wearing knickers entering the barbershop. This was the original site of Stewart's Drug Store, which later moved just a little bit south.

The proposed city charter was published in *The Berkley Review* prior to the election on May 23, 1932. Berkley had become a village in April 1923, but once it became a city it was able to lower taxes.

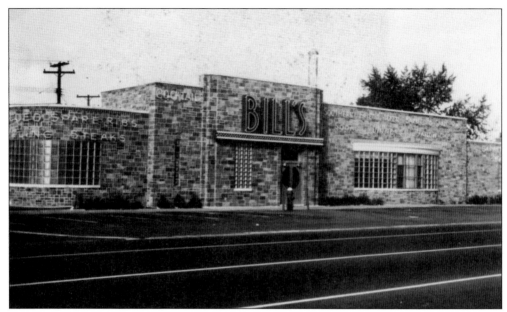

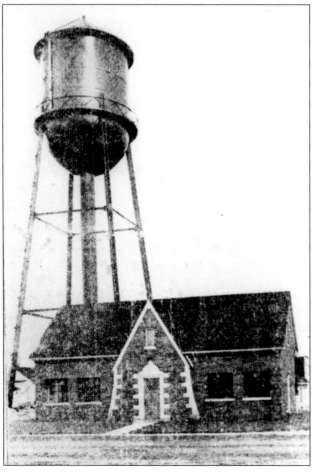

Bill Herman owned two restaurants on Woodward Avenue, both named after him. This one in Berkley was on the corner of Larkmoor Boulevard and Woodward. At first, it was just called Bill's, but later it became Bill's Northern to avoid confusion with his other place. Herman was famous for his roasted chicken. He lived in the house right behind the restaurant on Larkmoor. Later, he sold the building, and it became first Coral Gables and then Dillon's before it was torn down in 1989.

For years, Berkley relied on its 16 wells for its water. Finally, in 1928, this water tower was built on Bacon Avenue, south of Twelve Mile Road, at a cost of $32,709. After the city joined the Detroit water system in the late 1960s, the tower was torn down, and its scrap was sold for $500. The building in front of the tower, the pump building, now houses the Public Works Department.

This burned-out building housed the original Berkley Theater on the south side of Twelve Mile Road. It was built in 1928. On May 14, 1931, there was an explosion that destroyed the theater and other nearby stores. It was the biggest fire the village ever faced.

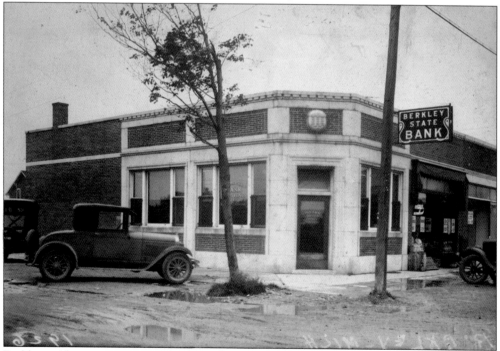

Berkley residents were very proud to have their own bank. The Berkley State Bank was located on Twelve Mile Road east of Coolidge Highway. The city and most residents had all of their money deposited there. In 1931, the bank failed during the Depression. In 1932, a grand jury charged the bank's president, T. Allen Smith, with embezzlement. No record exists of whether or not he was found guilty. (Courtesy of the Walter P. Reuther Library Archives.)

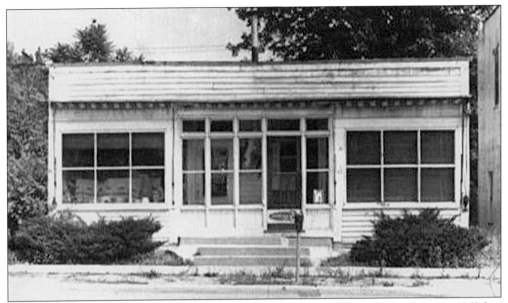

This is the outside of Bessinger's Market. Adeline Bessinger closed the business in 1969 but continued to live in the home attached to the back. The building was later torn down to make a parking lot for what is now a Telcom credit union branch. During the Depression, the store gave credit and helped many families in Berkley survive those grim days.

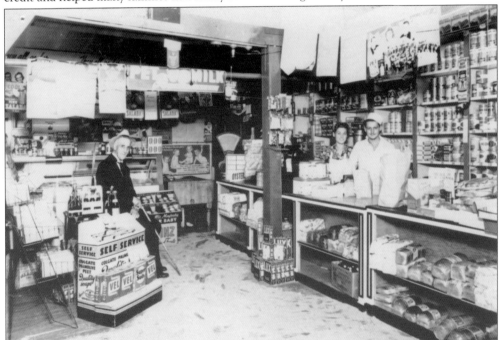

This is the inside of Bessinger's Market on Coolidge Highway. The store was built in 1919 by Adeline and Louis Bessinger. At first, it was a meat market called Monnier Cash Market but later became a grocery store. Note the poster hanging over the head of the sales clerk with the photograph of the famous Dionne quintuplets, who were born in 1934. They were used to advertise many products.

This 1950s aerial view of Berkley shows the old water tower that dominated the city's skyline. The public works building stands in front of the water tower. The tower was built on Berkley's highest point. In addition to the tower, Berkley had 16 wells for public use.

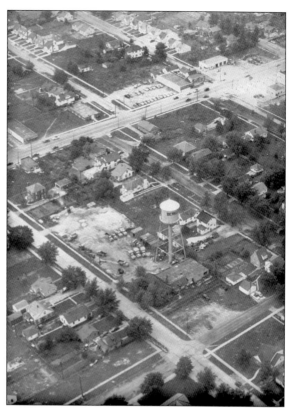

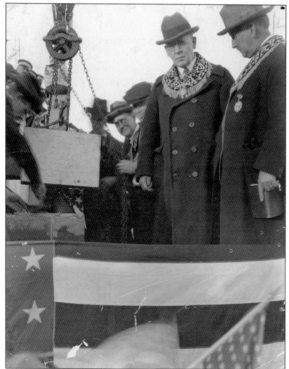

On December 14, 1923, the grand master and the chaplain of the Odd Fellows gather to dedicate the cornerstone for the new Odd Fellows Hall on Twelve Mile Road. The Odd Fellows supplied most of the leadership in early Berkley, and almost all village officials were members. Today, the building houses antique dealers.

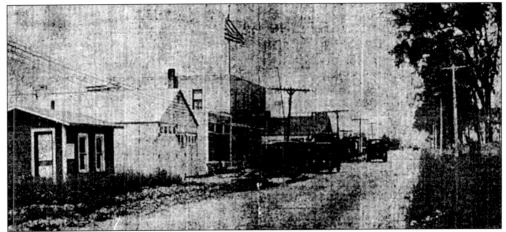

This faded photograph appeared in Detroit's largest newspaper, *The Detroit News*, on July 16, 1924. It was a mixed blessing that the newspaper noticed the village. The second paragraph reads: "It is a frontier community now, the edge of the metropolis pushing fan-wide northward. With the exception of a few details . . . it resembles a settlement in the oil waste of Wyoming."

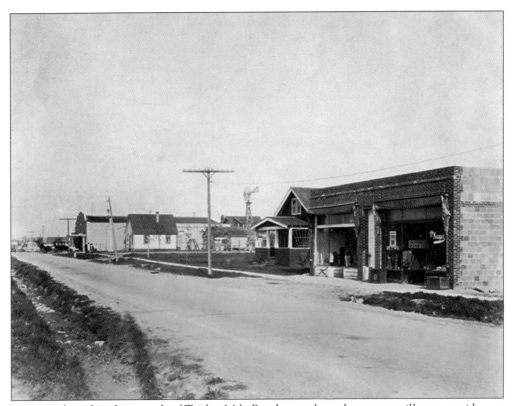

In 1925, when this photograph of Twelve Mile Road was taken, there were still many residences on the street. The large white building in the background (with cars parked in front) is the Odd Fellows Hall. The first building in the foreground was one of the many small grocery stores that dotted Berkley during this period. It was called Kroger's but had no relationship to the later national chain.

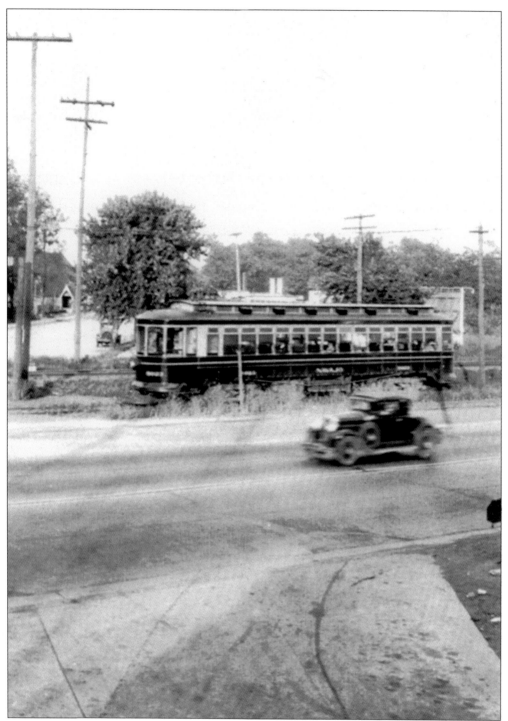

This 1920s photograph was taken looking at Woodward Avenue near Eleven Mile Road. By this time, the DUR had more than 400 miles of transit tracks in the Detroit area. There were several stops along Woodward in Berkley for transport to Pontiac or Detroit. In 1956, the last streetcar traveled down Woodward through Berkley.

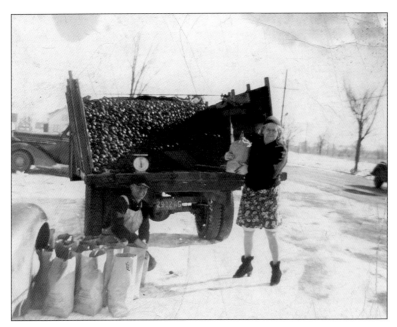

Ezra "Pop" Durst and his wife, Edith, are loading coal into paper bags for sale. The narrow unpaved road on the right side of the photograph is Eleven Mile Road. Selling coal was a major part of the Durst business for years, as most homes in Berkley were heated with coal. The truck is their 1934 Chevy, which held four tons of coal. (Courtesy of Jerry Durst.)

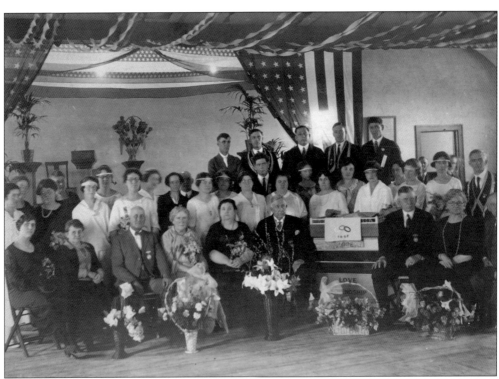

In 1923, the Independent Order of the Odd Fellows had outgrown their original wood building on Twelve Mile Road. In June, they formed a building committee to raise money and plan for a new Twelve Mile headquarters. Here, they all gather for their first meeting. The women's auxiliary was called the Rebekahs. The building still stands at Twelve Mile and Gardner Avenue but now contains antique dealers.

38

In the early 20th century, there were companies that would deliver an entire house in parts to home buyers. This Buckingham Avenue house was delivered by the Aladdin Company. Everything needed to build a house came in the kit, including nails, wood, and wiring. Homeowners could put the house together themselves or hire a contractor to do the work. Aladdin was based in Bay City, Michigan, and sold homes all over the world. (Courtesy of Carol Ring.)

Between 1908 and 1940, Sears sold over 70,000 house kits; they were the largest providers of such kits. There are several these homes in Berkley, including this fine example. Often, neighbors would gather to assemble them, much like a barn raising. (Courtesy of Carol Ring.)

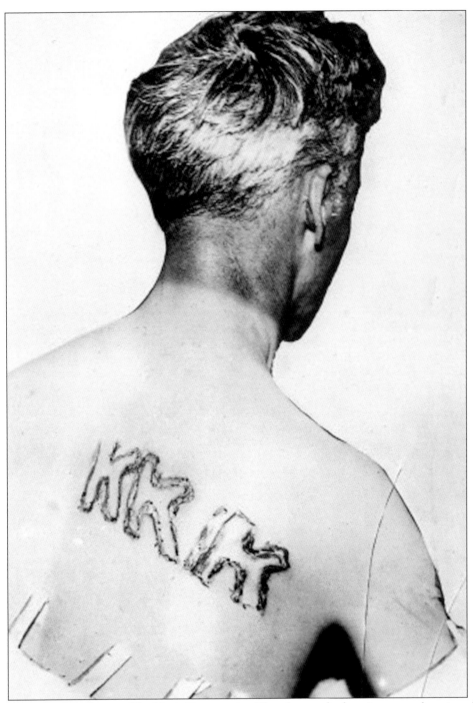

In 1924, Rev. Van Loon of Berkley's Community Church preached against cross burnings by the Ku Klux Klan. On June 30, 1924, he vanished after being kidnapped by the Klan. When he was found 11 days later in Battle Creek, he was delirious and cried, "Don't let them get me." He had been branded with KKK on his back. This photograph and the related story appeared in newspapers all across America.

Three

THE BOOM YEARS
THE 1940S AND 1950S

When the 1940s began, the nation and Berkley were in the depths of the Great Depression. It was the worst of times; however, by the end of the 1950s the nation and the city began to prosper beyond anyone's prediction. It became the best of times.

In 1930, the population of Berkley was 6,406. By the end of the 1940s, it had grown to 17,931. During the war years, people poured into the city, as Detroit became the "Arsenal of Democracy." The automobile industry converted to the war industry, and employment soared.

Berkley stepped up immensely during World War II. Hundreds of the city's men fought all over the world for their country, and many never returned home. The Exchange Club erected a large sign on city hall's front yard listing all of the men who were serving—and the list grew and grew. Berkley celebrated when the war was over, and the sign came down.

After World War II, the GIs returned home, found good factory jobs, and built houses. The day after the war ended, Berkley's local newspaper published an article titled, "Outlook Is Bright for City's Future: Employment within City to Reach New High."

It was during this post-war period that the Berkley known today really took shape. Most of the housing stock was built during this era. Schools that had been closed during the Depression were reopened; new ones were built, and the school population exploded. The Twelve Mile Road shopping strip filled in with favorites like Cunningham's, A&P, Kresge's, and Hiller's Shopping Center. Berkley claimed to be the fastest growing city in the country. The community was maturing.

The BERKLEY ADVANCE

Vol. 3, No. 24 — BERKLEY, MICHIGAN, AUGUST 16, 1945 — Berkley's Official City Paper

BERKLEY CELEBRATES VICTORY

Outlook Is Bright For City's Future

Employment Within City to Reach New High

Berkley, the city who has "grown up" during the war, looks forward now to the post war era. More than doubled in size since the start of the war, our city with its new form of government has definite post war plans.

Functioning more smoothly probably than at any other time in its history, the government of Berkley in recent months has changed to the City Manager type of administration and has adopted a new charter. Operating within its budgets, the administration has worked out, and put into operation, a refunding program, which now promises to lead Berkley out of debt.

In the schools, the post war period will show many changes. LaSalette school now under construction will be a valuable addition to the city and will aid in reducing the congestion of over crowded classrooms. Much additional building is planned at the Berkley school where a large auditorium gymnasium is planned for the near future.

Business has already stepped into its development as is indicated by the many buildings now in progress along the business district. Plans are taking shape to provide Berkley with all of the services needed in a well rounded community including a library, bank, post office, and stores.

The American Legion is completing its plans for a proposed $50,000 Legion home.

On Catalpa, the city has plans for a beautiful recreation park. The development of this project will start, it is thought, in the near future and when completed will include a baseball diamond, football field, track, tennis court, swimming pool, and community buildings. Berkley looks with real interest to the future.

Change Qualifications For School Electors

Effective after September 4, qualifications for school electors in Michigan need only to be 21 years of age, a resident of the state for six months and a resident of the school district for 20 days preceding the school election.

According to the new statute a new person need not own property or be parent of a child of school age to be eligible to vote for members of the Board of Education or in changing school tax rates.

So that a person's registration will continue "in good standing," he must vote once every two years or, if not voting, he must sign and return the notice of cancellation within 30 days.

Tank Destroyers Head for U. S.

Assembly Area Command, France —With a record of fighting with five Armies in four countries, the 772nd Tank Destroyer Battalion is en route to the United States.

Pfc. George B. Weaver, 2311 Royal Ave., and Pfc. Robert C. Smith, 2475 Cambridge road, were members of the unit.

The battalion entered combat last December 22, but stemmed the ensuing five months with action. Under the direction of Lieutenant Colonel Harry W. McClellan, of 2814 Hillcrest avenue, Augusta, Georgia, the men put in 143 days without relief in the Ninth, First, Seventh and Third United States Armies and the 1st French Army; and travelled thousands of miles in France, Holland, Belgium and Germany during the fiercest fighting of the war.

With the 75th Division, the 772nd formed the Northern Bank of Ruhr pocket and participated in the attack on Dortmund. They continued these forces and performed occupational duty in Warburg. Germany, until relieved to proceed through the Assembly Area Command's redeployment camps enroute to the States.

New Factory Has "House Warming"

The Metal Fabricates, the Tri-M, and Hamilton Products had a gala house-warming at their new plant, 3650 Eleven Mile road, August 8. Over five hundred people attended to congratulate A. Mitchell and T. J. Llewellyn on their new enterprise.

Claiming to be the first manufacturing people in Berkley, the owners dedicated their new building to the men and women in the service from their organization.

During the evening an orchestra played for dancing following the dedication program and lunch was served to the throngs which included Mayor M. J. Macgregor and City Manager Dave King who came to express congratulations on the enterprise. The owners expressed sincere appreciation to all who have contributed to the success of their organization.

VETERANEWS
from the
OFFICE OF VETERANS' AFFAIRS
Lansing

This is the emblem worn by an honorably discharged Veteran. Recognize it for what it means.

STATE LAND MADE AVAILABLE TO VETERANS

Exhibiting an eagerness to cooperate with Local Councils of Veterans' Affairs and the Michigan Office of Veterans' Affairs in their efforts to assist veterans in securing homes and business properties, the State Land Board announced a policy of giving veterans preference in buying property.

The program will be of particular interest to veterans in the Metropolitan area because most of the land the State has for sale lies in Wayne, Oakland and Macomb Counties. Gerald P. Mallory, Land Board secretary, estimates the State has 50,000 to 65,000 parcels of land for sale in these three counties.

Most of the parcels are vacant property platted for residences, but some business sites are included. However the Board controls all state land in all 36 counties lying below the north line of Muskegon County across the state, including Bay county and all the thumb.

The Land Board rules that a veteran who wishes to buy a State parcel at the appraised value for his own use and not for re-sale may do so without competition.

The land ordinarily must be sold at public auction subject to the highest bid. A civilian wishing to buy a lot must submit a bid and, if his offer is not accepted for seven days during which a higher bid may be entered.

The appraised prices of the lots in the Metropolitan area range at slightly higher than the assessed values, Mallory said. In the small town and rural areas, the appraisals run less than the assessments, he said.

Veterans interested should consult a counselor in a local counseling center, who will assist them in making the correct contacts. The counselor will be empowered to issue a certificate of eligibility to purchase.

School Census Shows 3,476 Students

The May school census indicates that approximately 150 more students were enrolled in the Berkley Huntington Woods school system at the close of school than a year ago. Three thousand, four hundred and seventy-six students between the ages of 5 through 19 were enrolled this year and 3,327 last year.

Three new teachers have been hired by the Berkley Huntington Woods Board of Education for the coming year. Resignations have also been accepted from three members of the school organization.

Science in the Junior high school will be taught by Wayne University students, Vernon Wolfe, of Detroit. He has recently taught at Grosse Ile and Otisville.

Replacing Grace Oxley, Rosaline Smith, of South of Detroit, will teach first grade at the Angell school. Formerly teaching in Hamtramck, Miss Smith has an A.B. degree from Wayne University.

Mattie LeRay of Teupelo, Miss. will teach an A.B. degree from Blue Mountain College, Miss., will instruct the fourth grade at Pattengill.

Boys, Girls Get Tiger Tickets Free

SOC Harvest Show Invites Gardeners To Show Exhibits

One hundred boys and girls in South Oakland county have a chance to win a free ticket to the Tiger-St. Louis baseball game on September 22 according to Mrs. Isabel M. Grunau, general chairman of the Third Annual South Oakland Harvest Show.

The show is to be held in the Oakland County Community Market Building in Royal Oak September 8 and 9. Boys and girls of South Oakland can win the free base ball tickets by getting not less than five exhibitors each to bring their produce and flowers to the show for exhibit. Schedules of the show can be secured from the regional chairmen listed below.

Entry instruction sheets have been placed in the hands of all of the Recreation Directors in South Oakland and in addition the following regional chairmen have the entry slips: Berkley, Simon DeWaal, 800 W. First Street, Li 2-5264; Clawson, Mrs. Charles Saylor, 4342 Crooks Road, R.O. 2463; Ferndale, Mrs. Floyd G. Byers, 265 W. Breckenridge Avenue, Li. 2-6088; Hazel Park, Mrs. Lenore Armour, City Office, Li. 2-3300; Huntington Woods, H. F. Andreasen, 13330 Elgin Avenue, R. O. 3613; Royal Oak, Mrs. William J. Chadwick, Recreation Office, R. O. 8750; Royal Oak Township, Mrs. E. H. Wells, 27371 Park Court, R. O. 6438-J; Troy Township, Mrs. J. H. Goodwin, 1515 Big Beaver Road.

The contest committee states that the first one hundred boys and girls who turn in the names of five exhibitors will be eligible for the free tickets BUT the final decision is made when the exhibitors are all in the show. Assuming that 125 boys and girls should submit five names each as exhibitors and then neglected to show the first 100 boys and girls are unable to get their five exhibitors to show then the next twenty in order will be eligible to compete for the free tickets.

The contest committee recommends the following:

1. Get five and preferably seven or eight people signed up as exhibitors at once. Have them sign their name and address and telephone number.

2. Turn your hats over to the regional chairman in your territory at once so that you can be one of the first 100 with their exhibitors all lined up. (If you are unable to get an instruction sheet just use a plain sheet of paper and get 5 or more signatures with addresses and telephone numbers signed up.)

3. Keep contact with your 5 or more exhibitors until they are actual exhibitors and you are in possession of your ticket to see the famous Tigers on the 22nd.

The contest committee wishes that they have another surprise up their sleeve so watch the Advance for new ideas on the contest.

IN THE SERVICE

GUAM—Mose D. Montreuil, seaman, second class, of Route 1, Clackston, Mich., has arrived at an advanced Island base where he is part of a special Seabee battalion. Montreuil, who left the States for the Pacific a month ago, reached his destination during a drenching tropical downpour.

T/5 William E. Baldwin, son of Mr. and Mrs. Elmer Baldwin, 3329 Franklin road, arrived recently to spend a month's leave with his wife, Juanita, and his parents. A 1943 Berkley graduate, Baldwin has been in service since March 1943. After training at Camp Gordon, Ga., he served a year with the third Cavalry Reconnaissance Squadron with the Third Army from France to Austria. He wears the European Theater ribbon with four battle stars and the good conduct ribbon.

S2/c Clifford Bradley, son of Mr. and Mrs. William Bradley, 2463 Lakes, Ill., he went overseas in

PEACE!

The American eagle, the bird of freedom, can now return the Victor.

May this demonstration of power show the world the strength that is possible when men are free. The world now looks to us for leadership. We are the "big brother" of a hundred nations.

As free people we have led the world to freedom.
IT MUST REMAIN THUS!

"Berkley Days" Program Will Feature Honor Roll

Featuring the names of Berkley's service men and women, the sixty-page Berkley Day program booklet is expected to be distributed to the homes and business places of Berkley, Tuesday, Aug. 21. The program telling the order of events and advertising Berkley Days, Aug. 23, 24 and 25, will be distributed by the Boy Scouts.

The souvenir program was compiled by Mrs. William T. Duncan with the aid of Margaret Collins and the office staff of the Berkley schools.

General chairman L. L. Fowler reports that plans for the holiday are taking shape and a "bigger and better" celebration is promised all comers.

Featuring two parades, a sports program, baseball game, exhibits, and a giant mid-way, the three-day festival is planned to be the greatest ever held in Berkley.

Dave King reports completion of midways plans which will include games wheels operated by the American Legion and Auxiliary and another by the Chamber of Commerce; a bingo stand will be operated by the IOOF Lodge and Lady of La-Salette will encourage the crowds to try and knock over the milk bottles.

Several of the other churches have indicated their intentions of feeding the crowds by placing orders for over a ton of meat.

Enlarging their last year's beginning, the Chamber of Commerce will have a large exhibit tent where merchants and manufacturers will display their products to the throng. The Ford Motor Company has indicated plans of using the center area of the tent for their elaborate display of post war products.

Charles Hooper Dies in Service

Charles William Hooper, S2c, USN, age 17, died at 4:30 a. m., Saturday, in the Naval hospital on Treasure Island, San Francisco, California, of a heart condition after an illness of a few days.

Son of William J. and Muriel (Dubnii) Hooper, 28400 Selkirk street, Southfield township, he was born April 19, 1928 in Detroit, and moved to Royal Oak one year later. He has lived in Southern Oakland county ever since.

He attended the Angell school and the Berkley senior high school until he enlisted on April 30. A year before he enlisted he was a member of the First Chemical company of the Michigan State Troops, Royal Oak. He left for Great Lakes on May 10, and was sent to Treasure Island, Calif., after finishing boot training on July 5. He had been active for many years in the Berkley Troop 2 of the Boy Scouts.

Besides his parents, Charles is survived by one sister, Joan, and one brother Robert, both at home; and his grandmother, Mrs. M. P. Mahoney, 706 East Sixth street, Royal Oak.

The body will arrive at the Virgo E. Kinsey Funeral home, Lafayette at Fifth street, Saturday, and the funeral is planned for 2 p.m. Monday at the Chapel. Full military rites will be performed with pall bearers, firing squad, and bugler attending from Ft. Wayne. Interment will be in Roseland Park cemetery.

The Advance and the community join in expressing sympathy to the bereaved family. Charles and his brother, Robert, were the first paper boys of the Advance.

Excitement Runs High Tuesday

Parades, Noise and Music Let Joy Be Known

In perfect tune with the rest of the world, Berkley raised its voice in joy when official word was given of the war's end. Tuesday evening. Demonstrations ranging from the hanging of a facsimile of his highness the emperor in front of the city hall down to all conceivable forms of noise making in the city, indicated its relief at the final good news.

After the long hours of nerve-wracking waiting which came on the heels of nearly four years of war, it was little wonder that everyone expressed their joy in one form or another.

While the fire whistle screamed from atop the city hall, cars raced back and forth with horns bellowing and flags flashing in the wind. Several parades of both young and old were seen marching with much noise and excitement on the streets of Berkley.

As the first flash of excitement subsided Berkley's populace gathered in groups and parties to talk and in other ways spend the evening in celebration of final victory. Many are known to have braved the traffic to participate in the "march of the million" in the heart of Detroit.

Rev. Zeisser Accepts Detroit Pastorate

The Rev. Charles G. Zeisser, who formerly was the pastor of the Trinity Lutheran church, will be installed as pastor of the Martin Lutheran church of Detroit at 8 p.m. Sunday. Installation will be by the Rev. E. T. Bernthal of the Epiphany Lutheran church of Detroit.

Rev. Zeisser came to Berkley 12½ years ago from St. John's Lutheran church in Rochester. He and his family made their home at 3226 Royal avenue.

The Ladies Aid Society of the Berkley church presented a check and a purse was given from the members and friends of the congregation to the Zeissers at a farewell party.

Their new home address is 2825 Miller avenue, Detroit.

Play Program Youth Saves 38 Tons Paper

Along with their play the boys and girls participating in the summer playgrounds program, collected 7,100 pounds of paper in Berkley. This paper was part of the 38 tons collected by the children of 23 playgrounds in Berkley, Royal Oak, Ferndale, and Hazel Park.

Frederick A. Malo

Frederick A. Malo, age 82, 705 Princeton road, Berkley, died Sunday.

Born Sept. 19, 1862, in Detroit, he had lived in Berkley for the last 12 years. He was a retired ship builder, and had formerly been employed for 30 years by the White Star Line. He was a member of the Shrine of the Little Flower parish, of the Shrine of the Little Flower Holy Name society, and a life member of the Three Score and Ten Michiganders.

Surviving Mr. Malo are his wife, Minnie; five children, Mrs. E. A. Mondfin, Edward C. Alfred R. Maldrum J., and Alger F. and seven grandchildren.

Rosary services will be held Wednesday at the William Sullivan and Son funeral home, 705 West First street, and prayer service at 9:30 a. m., Thursday, also at the funeral home. Requiem High Mass will be at 10 a.m., Thursday, in the Shrine of the Little Flower. Burial will be in Mount Olivet cemetery.

Oakshire, who came from Seattle, Wash., to spend three weeks with his parents. A 1938 graduate of Henry Ford Trade School and later a tool maker at the Ford Rouge plant, Henry entered the Navy in May 1944. After training at Great Lakes, Ill., he went overseas in

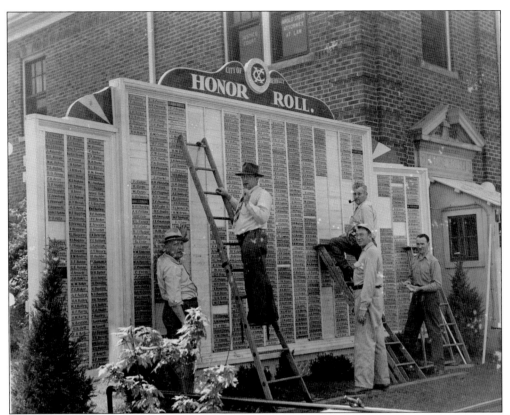

In 1943, the Exchange Club erected this Honor Roll on the grounds of city hall. It contains all the names of Berkley citizens serving their country in World War II. Since the population of the city was only around 6,500, almost all the young men were off fighting. The honor roll was taken down after the war, and in 1971 a monument honoring all of Berkley's veterans was erected at this spot. (Courtesy of Maybelle Fraser.)

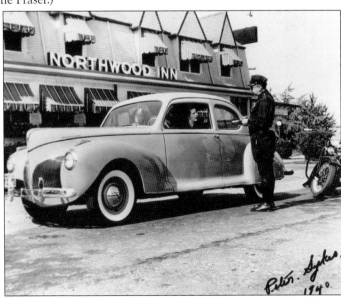

Officer Pete Sykes, the future police chief, was a motorcycle patrolman in this photograph. He is seen writing a ticket in front of the Northwood Inn, which is now the site of the Northpointe Medical Building on Woodward Avenue at the corner of Catalpa Drive.

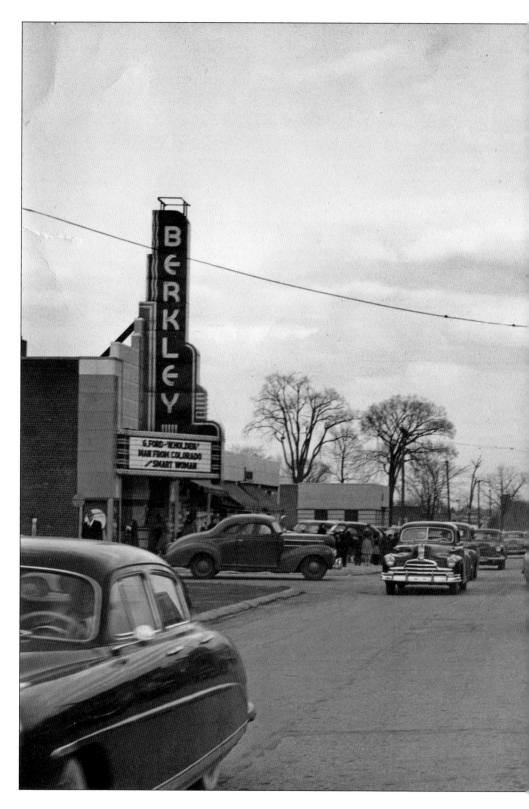

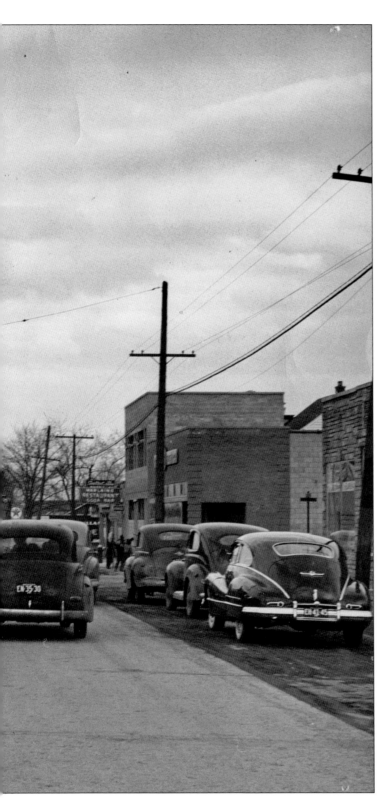

The downtown Twelve Mile Road shopping district was one of the busiest in Oakland County, here shown on a Saturday morning in 1948. Parking was always at a premium, and traffic jams were common due to the scarcity of traffic lights, which are notable absent. *Man from Colorado*, starring Glen Ford and William Holden, and *Smart Woman*, with Constance Bennett, were playing at the Berkley Theater. During this period, the theater always showed a double feature.

Berkley's real building boom started during World War II and then exploded soon after. The most typical Berkley home is the bungalow. These two-story houses line many streets in Berkley. Here, Shirley Hansen (left) and Darlene Greenleaf stand in front of typical homes built in 1943 on Princeton Road. During this period, these homes could be purchased for around $4,300. (Courtesy of Shirley Hansen.)

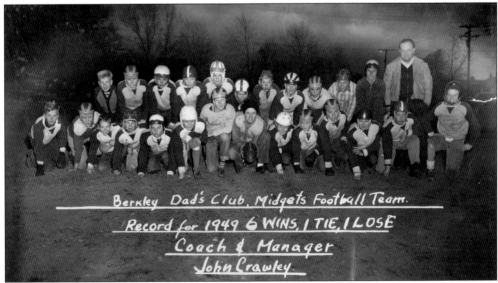

The Dads' Club was founded in 1948 to sponsor sports teams for Berkley's youth. It started with football and wrestling, but today it organizes baseball teams. Pictured is the midget football team from 1949. Its record of six wins, one tie, and only one loss is commendable.

The first location for the Sawyer Funeral Home was in this house on the north side of Catalpa Drive just west of Woodward Avenue. Edward Sawyer opened at this location in 1938. A few years later, he moved the business to another house on the southwest corner of Catalpa and Coolidge Highway before settling into the old Cromie farmhouse on Twelve Mile Road in 1944, where the business continues to operate. (Courtesy of Yvonne Fuller.)

This photograph of the Lucas farmhouse was taken just as workers were starting to tear it down. The building stood on the southwest corner of Coolidge Highway and Catalpa Drive. This was the second location for the Sawyer Funeral Home. After the house was demolished, Sunshine Food Store was located there, and later the building became the site of Family Video.

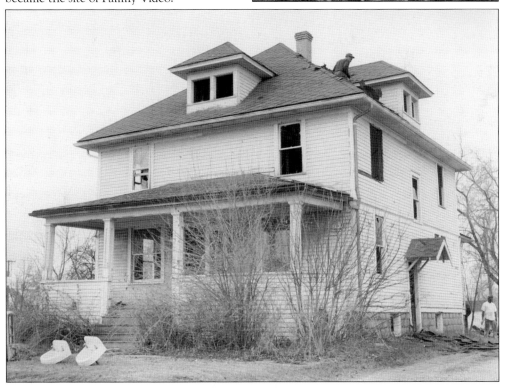

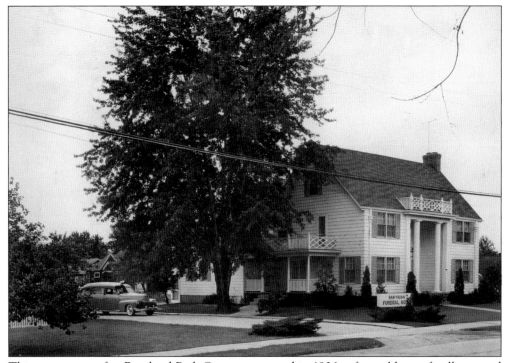

Thirty-two years after Roseland Park Cemetery opened in 1906, a funeral home finally opened in Berkley. Edward Harris started as an employee for the Harris Funeral Home in Detroit, but in 1938 he founded the Sawyer Funeral Home on Catalpa Drive. Harris later moved the business to Coolidge Highway. Then, in 1944, he bought the old Cromie farmhouse on Twelve Mile Road and started to expand the building into the large structure it is today. Bill Fuller married Harris's daughter Yvonne in 1955 and joined the family business, at which time Fuller was added to the company name. The Fullers continue to operate the business. (Courtesy of Yvonne Fuller.)

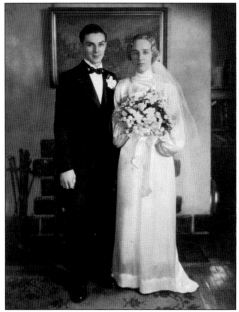

Edward Y. Sawyer stands next to his bride, Ileene Randolph, on their wedding day on October 10, 1935. This is her parents' home on Gardner Avenue in Berkley. In 1950, Ileene became the first woman in Michigan to graduate in mortuary science, after which she became a partner in the Sawyer Funeral Home business. (Courtesy of Yvonne Fuller.)

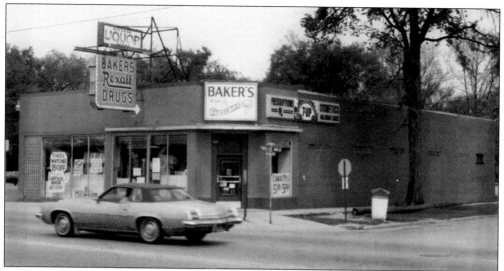

In 1946, Baker's Drug Store moved into this building at 2600 West Twelve Mile Road. In 1959, Raymond Lewis Baker sold the business to Max Millman, Milton Abramson, and Harold Elias. Max Millman's son James became a pharmacist and later took over the business. On May 24, 2007, James Millman closed the store and donated a sizable collection of historical drugs and prescription-making equipment to the Berkley Historical Museum, where it is on permanent display.

This is Raymond Lewis Baker, who opened Baker's Drug Store at 2600 West Twelve Mile Road. He later became active in politics and served first on the city council and later the Michigan State Senate. Baker's was the last independently owned drugstore in Berkley and, along with Nellie Davis and Stewart's, served residents of the city for decades. Baker's was one of the few stores that would deliver to people's homes.

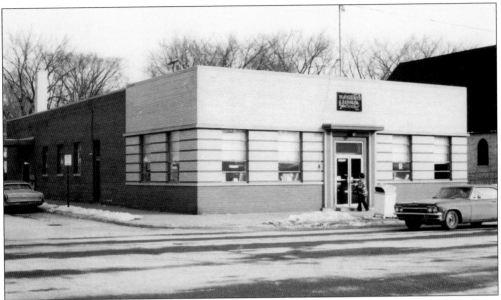

Berkley's first post office was located in a small frame building on the east side of Coolidge Highway north of Twelve Mile Road. In 1957, this brick structure was opened on the north side of Twelve Mile. In this 1971 photograph, the entrance was still on Twelve Mile. In the mid-1980s, the door was bricked over, and the entrance was moved to the Wakefield Road side, where it is currently located.

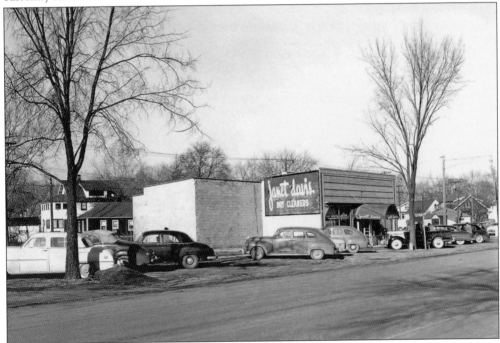

Janet Davis opened this dry-cleaning establishment at Woodward Avenue and Larkmoor Boulevard in 1950. The building looks very different today because it has been added onto twice. Notice the diagonal parking that was common on Woodward until the mid-1950s. (Courtesy of Janet Davis Cleaners.)

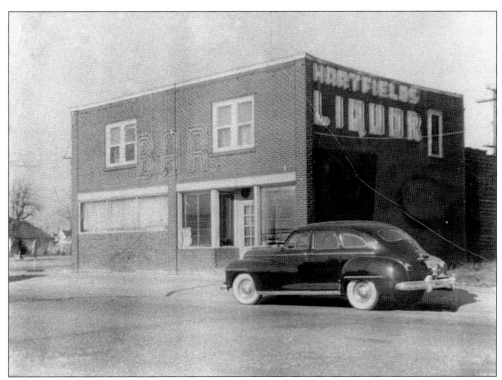

Harry Hartfield began his career as a bootlegger during Prohibition. The Purple Gang at one point tried to recruit him. In 1944, he bought the Twelve Mile Café and renamed it Hartfield's. He operated the bar with his wife, Mabel. Hartfield was known around Berkley as "Mr. H" and lived to celebrate his 100th birthday. (Courtesy of Harry Hartfield.)

This photograph shows the interior of Hartfield's second bar on Twelve Mile Road. This brick building replaced the original wood structure. The bowling alley that opened in 1959 was built around the structure. The local newspaper reported that this bar brought "a touch of elegance to Berkley." (Courtesy of Harry Hartfield.)

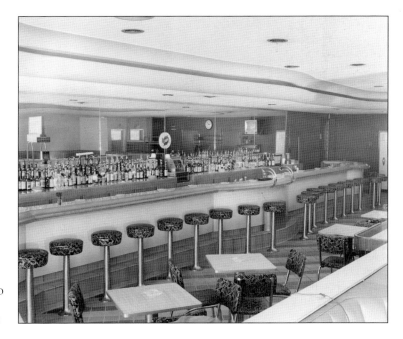

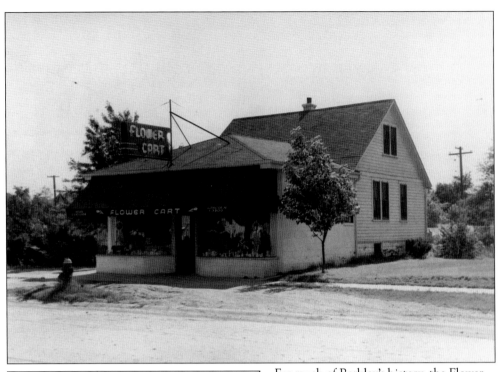

For much of Berkley's history, the Flower Cart stood at 2523 Coolidge Highway. Along with the Flower Shop on Twelve Mile Road, it provided most of the flowers for Berkley's weddings and funerals. John and Sicily Crowley ran the Berkley Flower Cart for years and helped thousands of nervous Berkley brides through their big day. (Courtesy of Yvonne Fuller.)

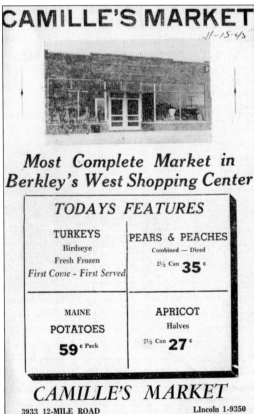

CAMILLE'S MARKET

-11-15-45

Most Complete Market in Berkley's West Shopping Center

TODAYS FEATURES

TURKEYS	PEARS & PEACHES
Birdseye	Combined — Diced
Fresh Frozen	2½ Can **35**ᶜ
First Come - First Served	
MAINE	APRICOT
POTATOES	Halves
59ᶜ Peck	2½ Can **27**ᶜ

CAMILLE'S MARKET

3933 12-MILE ROAD LIncoln 1-9350

Before World War II, there were many privately owned grocery stores in Berkley, and most people could easily walk to one. Camille's, shown here, opened first on Twelve Mile Road in 1945. The store was later moved to Coolidge Highway next to Berkley Auto Parts and across the street from Our Lady of LaSalette Church. When Camille's went out of business, LaSalette bought the building and used it as a parish center.

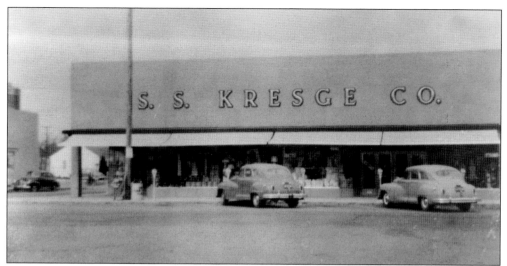

S.S. Kresge's stood on the northeast corner of Twelve Mile Road and Griffith Avenue for over 30 years. It opened in 1946 right after World War II when the Twelve Mile shopping district greatly expanded. Residents still fondly remember the squeaky wood floors and soda fountain where shoppers could have a soda and sandwich after a long day of shopping. When the store closed, it was replaced with Harrison Luggage but now houses Rightmoves consignment shop and the TLC restaurant.

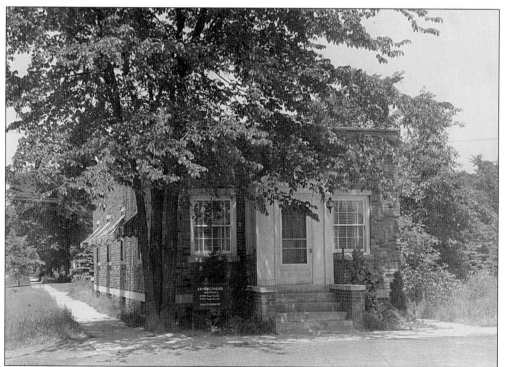

In 1943, when this photograph was taken, there were three doctors in Berkley. This is Dr. A.B. Newcomb's office at 2790 Twelve Mile Road. Dr. Newcomb practiced here for over 30 years. The other doctors in 1943 were John Norup and C.E. McMehen. There was one dentist in 1943, J.L. Rasmussen. This building later became the first home for Guildcrafter's Quilt Shop.

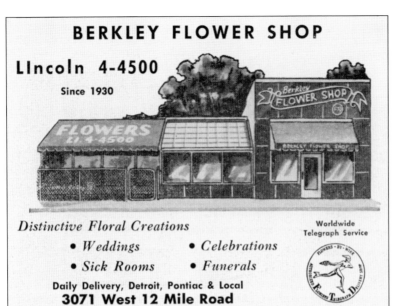

BERKLEY FLOWER SHOP

LIncoln 4-4500

Since 1930

FLOWERS
LI. 4-4500

Distinctive Floral Creations

- *Weddings*
- *Celebrations*
- *Sick Rooms*
- *Funerals*

Worldwide
Telegraph Service

Daily Delivery, Detroit, Pontiac & Local
3071 West 12 Mile Road

In 1930, the Berkley Flower Shop opened on the south side of Twelve Mile Road. It was owned by the Kuhn family and for many years was the only flower shop in Berkley. The store slowly grew to cover three lots and included a greenhouse and garden in the back.

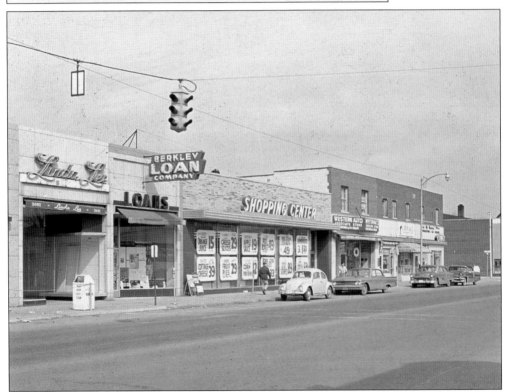

This photograph shows the north side of Twelve Mile Road in 1962. The only store still there is Hiller's Shopping Center, which has since expanded into the buildings formerly occupied by Linda Lee (a woman's clothing store) and the Berkley Loan Company. Western Auto, seen to the right of the Shopping Center, actually sold mostly bicycles and bicycle equipment. The Shopping Center was the first grocery store owned by the Hiller family. They now own seven stores in the metropolitan area.

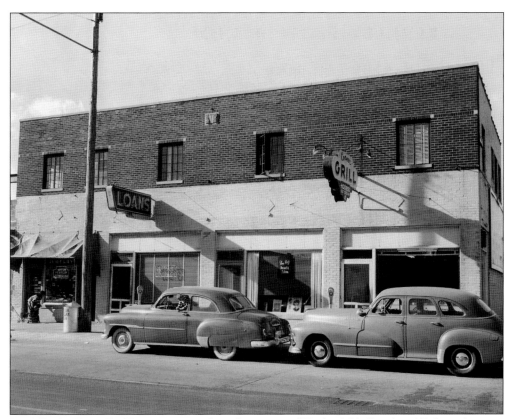

In 1952, the Trace Building was erected on the corner of Twelve Mile Road and Robina Avenue. It originally was only one story and housed offices and stores. Sometime later, a second floor was added. A long line of restaurants has occupied this corner over the years, the most recent being Kam's Chinese Takeout.

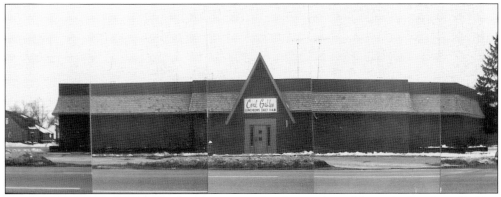

Coral Gables (previously Bill's Northern) was a popular place to eat and dance for decades in Berkley. It was located on the corner of Woodward Avenue and Larkmoor Boulevard. Unfortunately, it was built 50 feet above a major county water main that had to be repaired. Consequently, the building was torn down, and the land was later sold to a company that built the Westborn Market.

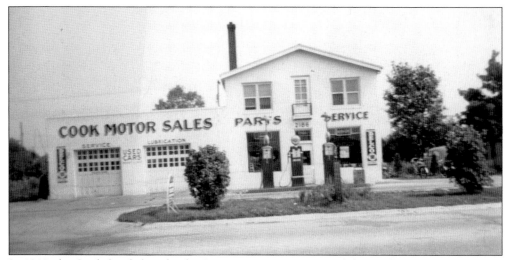

In 1940, the Cook family bought the Sunoco gas station on Coolidge Highway across the street from Our Lady of LaSalette Church. For years, they sold used cars as well as auto parts and gas. As the years went by, the building grew in every direction with multiple additions. The family lived on the second floor, but while that residence still exists, it is now hard to spot. (Courtesy of Robert Cook.)

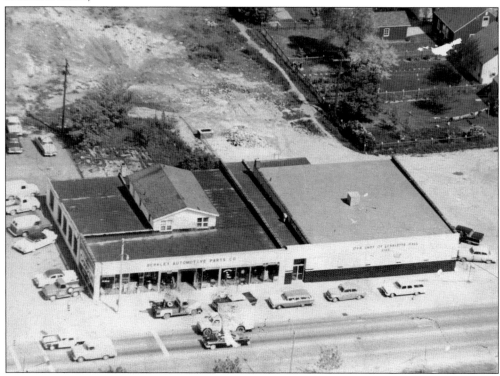

In 1940, Robert W. Cook and his family bought the Sunoco gas station on the corner of Coolidge Highway and Oxford Road. The gas business was not very profitable, so they decided to concentrate on selling auto parts and named their business Berkley Automobile Parts Co. This photograph shows the building in 1974. The structure on the right was being used as the LaSalette parish hall. The land behind the store was cleared to make room for Oxford Towers. (Courtesy of Speedy Auto Parts.)

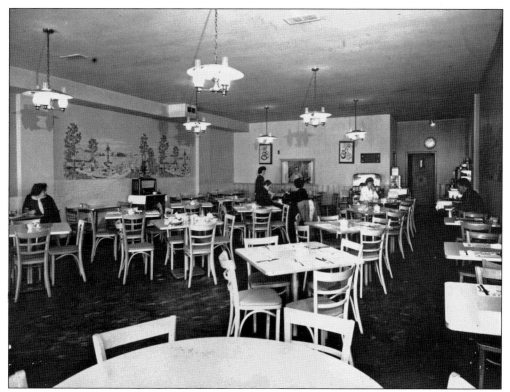

Dominico's Italian Restaurant stood on the west side of Coolidge Highway just south of Wiltshire Road for over 30 years. Dominico's and Sila's (the latter still stands on Twelve Mile Road) were the go-to pizza spots in Berkley. This image shows the main dining room of Dominico's in the early 1960s. (Courtesy of Mike Cotroneio.)

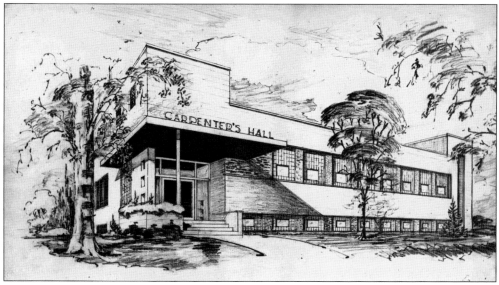

Carpenters' Hall stood on the south side of Twelve Mile Road across the street from Roseland Park Cemetery. It was the headquarters for the local Carpenters' Union and also provided banquet facilities for many events. There is now a Beaumont Sleep Evaluation Clinic on the site.

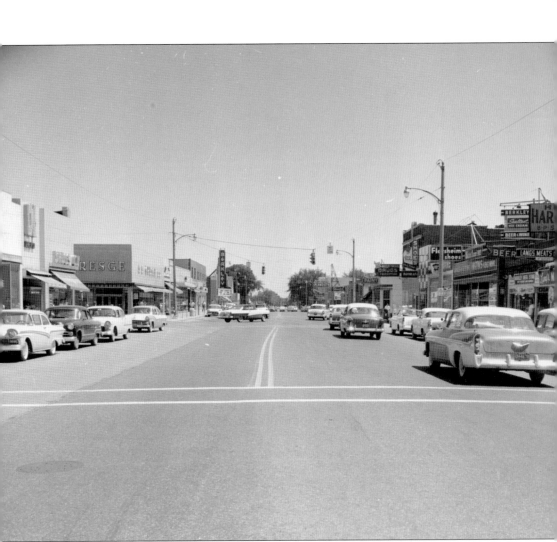

This late-1950s photograph shows the Berkley Twelve Mile Road shopping strip at its peak. Cunningham's Drug Store, Kresge's Dime Store, Shopping Center Grocery, and the Berkley Theater can be seen clearly on the left (north) side of the street. On the right side (south) are Hintz's Hardware, Florsheim Shoes, Nellie Davis Drugs, Tip Top Restaurant, and the short-lived Plymouth car dealership. Though changed, downtown Berkley seeks to regain this level of activity. (Courtesy of the Walter P. Reuther Library Archives.)

Four

BERKLEY BLOSSOMS
FROM 1960 TO THE PRESENT

By the late 20th century, Berkley was facing complex issues similar to those confronting most of its suburban neighbors. Because the city had few empty lots left to build on, the population stagnated and then declined. The city's population peaked at 23,275 in 1960, and by 1990 it had fallen to 16,960. People were having fewer children, and the declining school population led to the closure of Oxford School. On the other hand, the percentage of senior citizen residents increased, and their particular needs, including housing and activities, had to be addressed.

In 1954, Northland Shopping Center opened in Southfield, and by the 1960s the shopping districts at Twelve Mile Road and Coolidge Highway were in rapid decline as store after store closed. By the time Kresge's closed in 1982, there were very few stores left in the city. A 1968 study reported in *The Detroit News* that Berkley was a city "verging on terminal apathy."

City leaders fought back with a plan to build the Berkley Center, a large shopping center, on land to be cleared from Coolidge to Kipling Avenue and from Twelve Mile to Wiltshire Road. It was to cost $3,421,900, and Berkley residents invested over $100,000 in the project before it collapsed for lack of sufficient funds.

During this period, major improvements to the city were made. The new Berkley Public Library opened in 1960, and for the first time the library had a modern facility. The Twelve Towns Drain finally ended the constant flooding that Berkley residents had struggled with, and all of the streets were paved. A community center and a skating arena were constructed. In 1975, senior citizens began moving into the 214 apartments of Oxford Towers.

Berkley's shopping district was finally revitalized in 1993 with the formation of the Downtown Development Agency. This organization worked with businesses to attract specialty stores to the city.

All in all, Berkley met the challenges of the late 20th century with great confidence. The people of Berkley knew that with all they had overcome since the first settlers arrived, no challenges of the 21st century would defeat them.

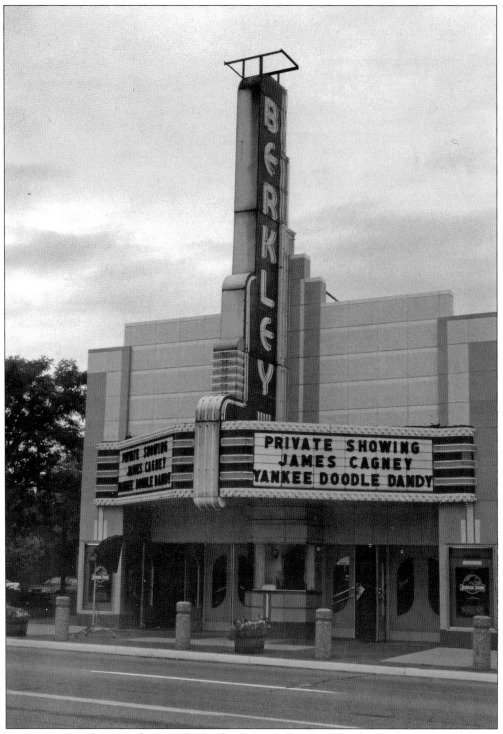

James Cagney's classic *Yankee Doodle Dandy* was specially selected to be the last movie shown in the Berkley Theater on September 26, 1993. Admission was by invitation only. The Art Deco structure was built in 1941 by Vincent Laica and John Igna.

Here are samples of many of the ticket stubs from the Berkley Theater. The prices range from 7¢ to $2.50. By the time the theater closed, it charged a budget price of $1. Some of the movies identified include *A Clockwork Orange* and *Summer of 42.*

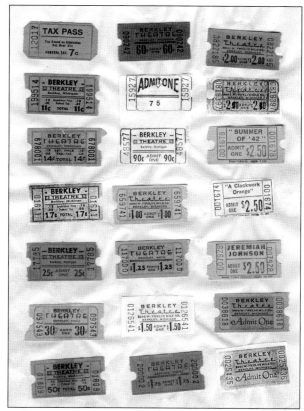

September 26, 1993, was closing night for the beloved Berkley Theater. The building opened in 1940 and could seat 851 people. This photograph shows the hallway on the last night. The stairs on the right led to the restrooms and the cry room on the second floor.

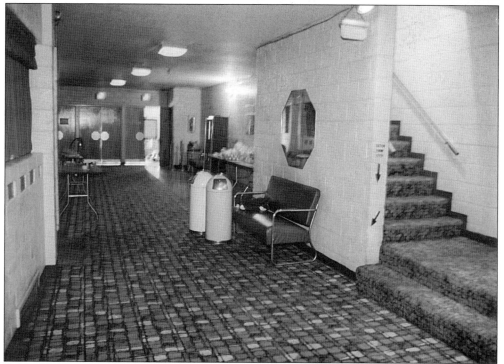

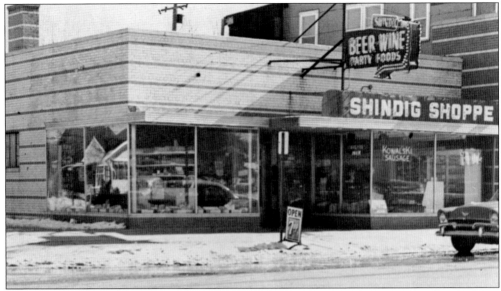

The Shindig Shoppe was the leading party store in Berkley for 40 years. It stood on the southeast corner of Coolidge Highway and Earlmont Road. Richard and Fred Dickow bought the store in 1966 and operated it until 1995, when they sold the building. It was the routine stop for Berkley High School students after school and was a major sponsor of Little League teams in all sports.

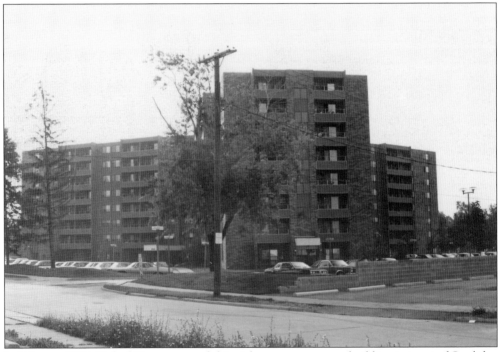

In February 1975, Oxford Towers opened this eight-story apartment building just east of Coolidge Highway on Oxford Road. It immediately became and remains the tallest structure in the city. It contains 214 senior citizen apartments. Such a facility was long sought by Berkley residents who did not want to leave the city when they grew older. Rent was originally based on income.

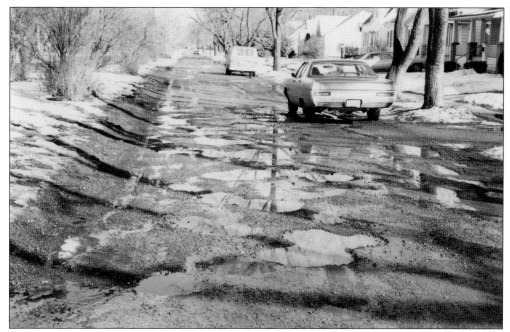

This is Larkmoor Boulevard in 1974. Most Berkley streets were noted more for their large chuckholes than for their usefulness. Streets were only paved when residents took up a petition and agreed to cover the cost through an assessment. It was not until the late 1970s that all streets were finally paved.

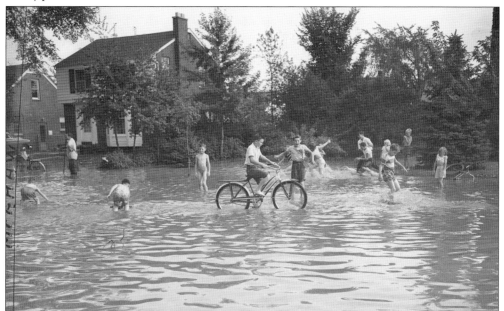

For most of Berkley's history, this was a common sight after every heavy rain. Most streets and basements flooded because the sewer system just could not handle the load. As a result, many residents placed their washers and dryers on small platforms in the basements. Here, children play on Catalpa Drive in the water in 1958. Finally, in 1961, the Twelve Towns Drain system was completed, and the flooding became just a memory. (Courtesy of the Walter P. Reuther Library Archives.)

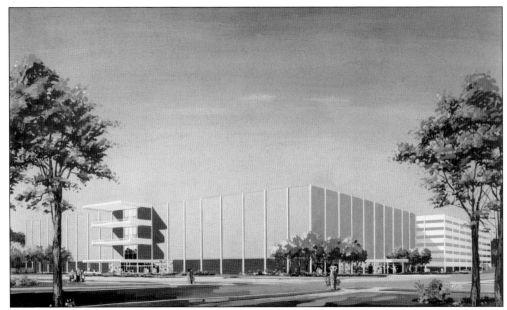

In July of 1964, plans were announced to build the Berkley Center to compete with Northland and other enclosed shopping malls. The complex would have stretched from Coolidge Highway to Kipling Avenue and from Twelve Mile Road to Wiltshire Road and cover 30 acres. The proposal included buying and tearing down 114 homes and businesses.

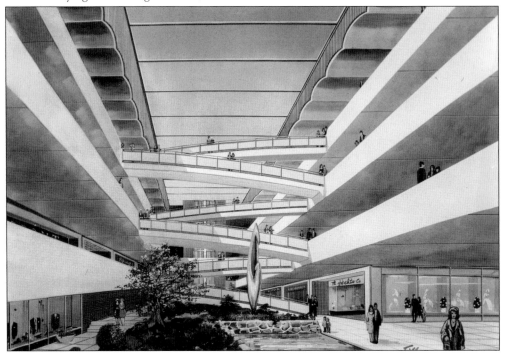

This artist's rendering shows the inside of the proposed Berkley Center. Edward Sawyer was president of the board that tried to raise money for the center. The complex was estimated to cost up to $3,421,900. Mayor George Kuhn and every member of the city council were among the investors. Over $100,000 in shares were sold, mostly to Berkley residents, before the entire plan collapsed.

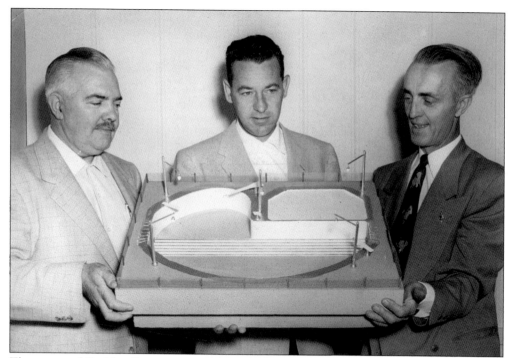

The proposed Berkley Center was not the only dream project that failed to be realized. Here, from left to right, Bill Herman, William Judy, and Mitch Elaniley proudly hold up the model for the new swimming pool that citizens had wanted for years. Unfortunately, the funding to build and operate this 1956 dream never did materialize.

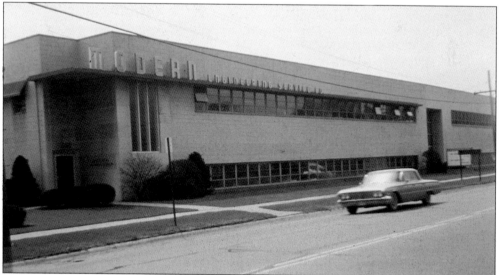

Modern Engineering Service Co. occupied the largest building in Berkley on the south side of Twelve Mile Road, one block west of Woodward Avenue. The company was also one of the largest employers for many years. In the mid-1980s, the company first relocated to smaller quarters in Royal Oak and then went out of business, one of the many victims of the decline of the American auto industry. New owners spent $4 million to turn the building into medical offices. This 1964 photograph shows the engineering company still thriving.

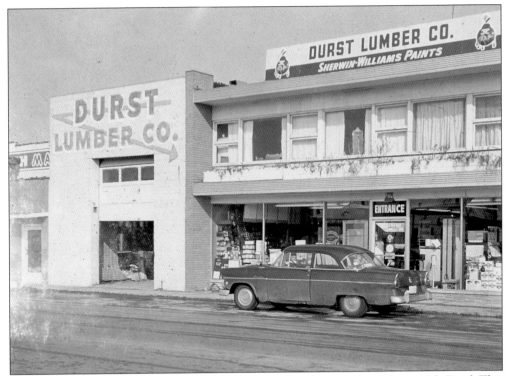

In 1940, Charles E. Durst opened Durst Lumber Co., a hardware store on Eleven Mile Road. This mid-1950s photograph shows the company's third building. The first building was the size of a two-car garage. Originally, Durst's main business was coal, but the store grew quickly, expanded its merchandise, and eventually occupied 10 city lots, each 22 feet wide. The store still operates today with the fifth generation of Dursts serving their loyal Berkley-area customers.

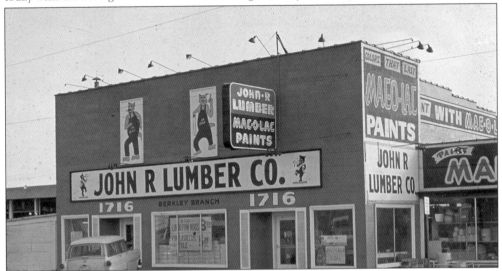

Isadore Katz opened Coolidge Lumber and Supply on the northeast corner of Coolidge Highway to compete with Durst Lumber right next door. The store failed in a few years, and he leased the building to a grocery store. After another few years, he reclaimed the property and opened yet another hardware store under the name of John R Lumber. He failed again.

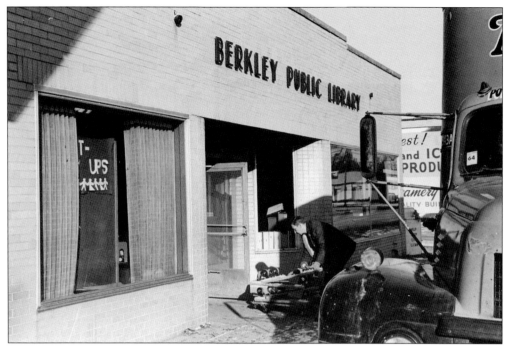

It was moving day for the Berkley Public Library in 1975. Boy Scouts and other volunteers moved 28,000 books that day from this rented space at 2799 Coolidge Highway to the new building three blocks north. The first library was organized by the Berkley's Women's Club and was housed in the Commission Room at City Hall.

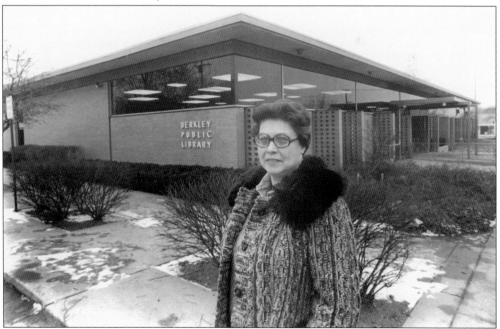

Head librarian Dorothy Levy stands outside the Berkley Public Library exactly 10 years after it opened on January 25, 1975. The building cost $197,000. Since then, it has been renovated, and the public entrance was moved to the south side of the building.

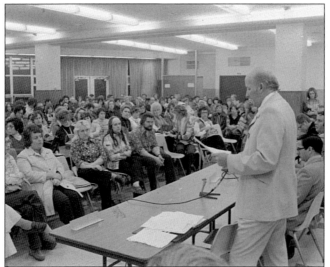

Ten-year-old Kristine Mihelich was last seen alive on January 2, 1977, at the 7-11 on Twelve Mile Road and Oakshire Avenue. Her body was found 19 days later. She was one of four children said to have been murdered by the Oakland County Child Killer in 1976 and 1977. These unsolved murders horrified and terrorized the community. In this photograph, Berkley residents have gathered to hear a report about the state of the investigation. (Courtesy of the Walter P. Reuther Library Archives.)

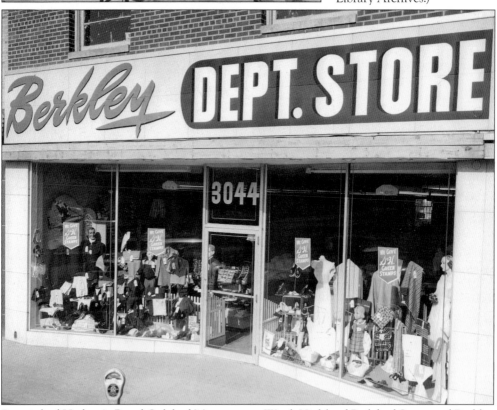

Detroit had Hudson's, Royal Oak had Montgomery Ward, Highland Park had Sears, and Berkley in 1953 had its own department store, located just east of the current Hiller's Shopping Center. For many years after, Western Auto Parts Store occupied this location. During the period illustrated in the photograph, Twelve Mile Road was a major shopping district that attracted buyers from all over the area; however, two years later, Northland Shopping Center opened on Greenfield Road in Southfield. Soon many stores in Berkley closed as shoppers migrated to Northland and other new malls.

In the 1970s, the Berkley Community Center opened on Robina Avenue just south of Catalpa Drive and immediately became a center of activities. Nancy Sydanmaa became senior citizen supervisor and began an extensive series of programs for Berkley's older residents. The center became the site of most community groups' meetings and activities, including dances and art exhibits.

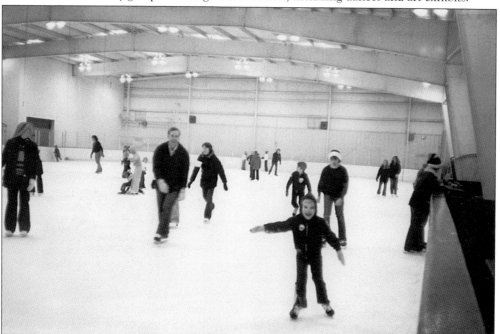

The City of Berkley had long provided outside ice arenas on park and school land. This was inadequate for planning hockey events because the weather did not always cooperate. In the early 1970s, Mayor Robert Eck and the Dads' Club led the drive to build an ice arena. Here, families are enjoying open skating in 1977.

The stone house at 1755 Royal Avenue looks like a castle to many Berkley residents. This is the Novitsky home; it is surely Berkley's most unusual residence. At the turn of the century, there was a dog food factory on Eleven Mile Road, and the owner built a small home next to it. As the house grew, stones were collected to make this distinctive dwelling. At the tops of the buttresses are stones shaped like dog heads. The dog food factory later became a tool and dye shop and then burned down on Christmas night in 1945.

This May 20, 1992, photograph was taken shortly after Dearborn-based Westborn Market opened on the west side of Woodward Avenue in Berkley. It occupies the site of the former Coral Gables nightclub. To accommodate the parking lot, Larkmoor Boulevard was closed at Woodward. A few years after this photograph was taken, the market underwent a major expansion. (Courtesy of Westborn Market.)

George Kuhn was mayor of Berkley from April 1959 until he resigned in April 1966 after moving out of the city. He is one of the longest-serving mayors in Berkley's history. During his tenure, the Twelve Towns Drain was completed, a new library was built, and the Berkley Center was proposed but failed.

When the City of Detroit decided in 1962 to impose an income tax on non-residents who worked in the city, opposition exploded in the suburbs. No one was more opposed than Berkley's own mayor, George Kuhn. He led the statewide petition drive to try to stop the tax. Here, he leads a group of citizens tossing tea into the Detroit River. Their efforts failed, though, and the tax was enacted.

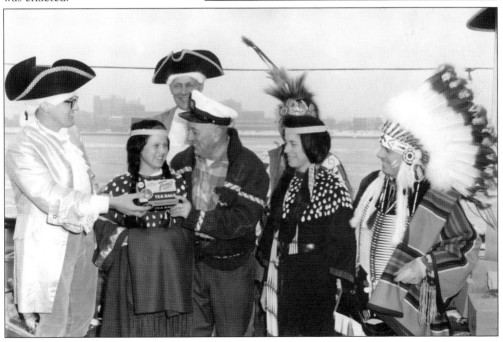

There was a period in Berkley's history when most of the elected officials were members of the Dads' Club. Many of them are gathered here in 1979 to inspect the new look of Twelve Mile Road. From left to right are Bob Eck (mayor), Ron Norman (councilman and later mayor), Bill Wagoner (city planner), Fred Restom (councilman), Tom Guirey (councilman), and Bob Best (councilman).

Over the years, Berkley has tried many times to beautify downtown Twelve Mile Road. In the early 1970s, a large federal grant was used to create attractive sidewalks edged in redbrick and to plant trees along the road. Parking has come and gone several times over the years. In 2009, the streetscape was changed again, and parking returned.

To celebrate the bicentennial of the US Constitution, Berkley planted a red maple tree, a sapling from George Washington's Mount Vernon, on the lawn of city hall on October 4, 1991. This was part of a national campaign led by William Burger, the chief justice of the Supreme Court. Alas, the tree died.

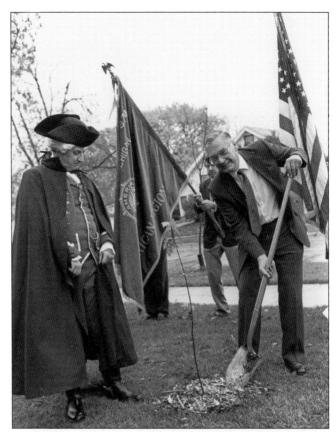

On Sunday afternoon, April 9, 1978, Berkley saw what was probably its biggest fire ever when Holland Hardware burned down. Flames and smoke could be seen for miles. It took 30 firemen from three cities to put out the blaze. Exploding gun shells and aerosol cans posed a serious hazard. Established in 1919 on Twelve Mile Road, Holland Hardware was the first retail store in the city.

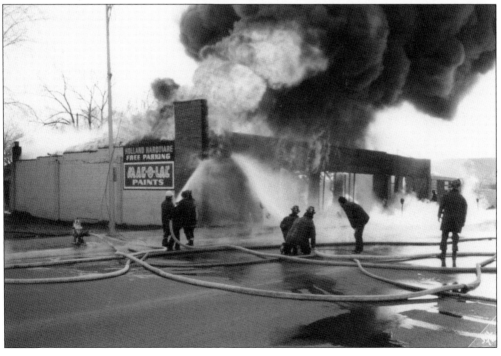

One of the biggest controversies in Berkley's history grew out of the 2002 paving of the Twelve Mile Road and Coolidge Highway intersection. Downtown Development Authority funds paid for the project. Soon after the paving was completed, the bricks began to crumble. The problem was caused when the construction company used the wrong type of bricks, and drainage issues arose. Lawsuits ensued, and the city received a settlement. In 2012, the intersection was repaved with concrete.

On Memorial Day 2001, the Berkley Gazebo was dedicated, thus completing a long-held Berkley dream for a village green for celebrating public events. When Maybelle Fraser became mayor, she started a fund with the money people gave her for performing weddings, beginning in 1995. After she left office, Fraser continued to raise money and recruit volunteers to complete the dream, and the gazebo was the result. The Veterans' Monument in front of the gazebo was dedicated in 1971.

Five

SCHOOL DAYS
EDUCATING THE CITIZENRY

Before water pipes were laid, before churches were built, before police were introduced, in fact before anything was established in Berkley, schools were built. It is no exaggeration that as soon as settlers arrived, the first thing they thought about was the education of their children.

In 1840, Blackmon School was part of the Royal Oak Township District No. 7. Berkley's first school stood on the corner of Catalpa Drive and Coolidge Highway (then Blackmon Lane) from 1840 to 1901. It was named after Lymon Blackmon, who donated half an acre of his farm to erect a school. Boys sat on one side of the school and girls on the other.

Blackmon School became an icehouse when a new school was built on the corner of Twelve Mile Road and Coolidge in 1901. Named the South School, this one-room schoolhouse educated children only through the eighth grade. People who wanted to further their children's education had to send them to Birmingham or Royal Oak and pay tuition.

By 1918, it was clear that a better school system was needed. Residents voted 34-0 to change to a graded school district. A new Berkley School was built, and in 1926 a high school was added.

The rapid growth in population starting in the 1920s led to the construction of more facilities. Angell School was built in 1921. In 1925, both Pattengill and Burton were added, but when the Great Depression hit Berkley in 1930, both of these had to close due to a lack of funds. They were not reopened until the 1940s.

Another boom period in school construction followed the end of World War II with the opening of Berkley High School (1949), Tyler and Oxford (1951), Hamilton (1952), and Anderson Junior High School (1957). When the school population began to decline in the 1970s, Tyler and Oxford were closed. Nevertheless, the dedication of Berkley's citizens to supporting a superior educational system has never wavered.

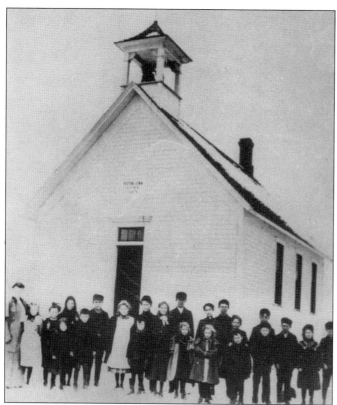

This 1907 photograph shows Baker School. The teacher, Josie Gannon, stands on the far left with her class. Sometimes this was called the South School because it was south of the first Berkley school. Baker School was built in 1901 and stood on the northeast corner of Eleven Mile Road and Coolidge Highway. It existed until 1920, when it became a dormitory for teachers. The school bell is now found in the Berkley Historical Museum, where children delight in ringing it.

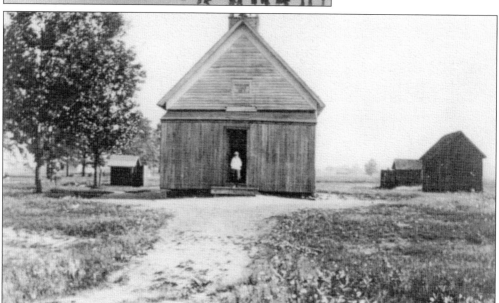

Berkley historians differ as to the true identity of the school in this photograph; however, the predominant theory is that this is Blackmon School. Located at the northeast corner of Coolidge Highway and Catalpa Drive, it was the first school in what is now Berkley. It takes its name from Lymon Blackmon, who in 1834 donated a half acre to be used exclusively for a school. It was built in the late 1830s.

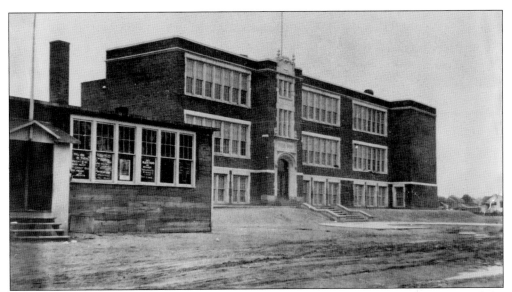

Berkley School sits behind the temporary tar paper school, which provided classrooms until the permanent school was completed in 1919. Berkley School was the first building in the city with electricity. The school went only up to the sixth grade, after which the students had to attend classes in Royal Oak or Birmingham.

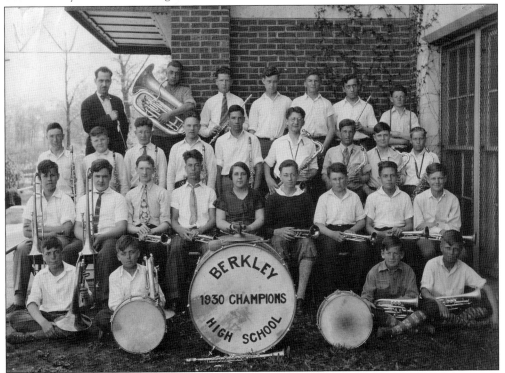

From the very beginning, Berkley High School offered almost every extracurricular activity that existed, and students excelled at many of them. In 1930, the high school won the State D Championship for school bands. Here, they proudly stand outside the school on Catalpa Drive. Ever since then, the school has had an outstanding music department.

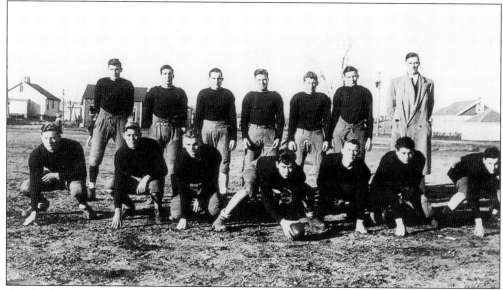

Coach Fleming had one of Berkley High's best football years with this 1934 team. They defeated their traditional rivals, Royal Oak and Hazel Park, and only lost one game (against Northville). The team tied for the Suburban League championship.

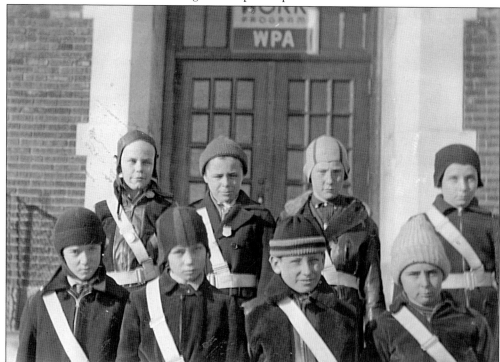

The all-boy Berkley Safety Patrol stands outside Berkley School in 1936. Notice the WPA sign over the door. The Works Progress Administration was one of President Roosevelt's programs to fight the Great Depression by providing money for a wide variety of local government programs. It had only been created the year before and was already sending money to Berkley public schools. Later, federal funds were used to repair Pattengill so that it could be reopened after the Depression.

Most of the teaching staff of the Berkley School District is lined up on the steps of Berkley School in 1926. The school stood near the northeast corner of Catalpa Drive and Coolidge Highway across the street from the site of the current high school. It is noteworthy that the entire teaching staff was female.

This image shows the June 1931 graduating class of Berkley High School. Like most schools of the time, Berkley graduated students in January and June every year. Principal Milburn P. Anderson (center) became superintendent of the Berkley School District in 1939. Anderson Middle School is named after him. Berkley schools experienced a difficult year in 1931, as the Depression forced the closing of Burton and Pattengill.

In 1925, Pattengill School opened on Morrison Avenue between Oakshire and Royal Avenues, pictured here in 1975. It was named after Henry M. Pattengill, who had been superintendent of Michigan Public Instruction. When the Great Depression struck America, the number of Berkley students declined, and the school budget took a major hit. Consequently, the district closed Pattengill in 1930. It was not until 1941 that the school was reopened, but the structure had deteriorated in the interim. In 1943, the city received a federal grant of $10,300 to renovate the school.

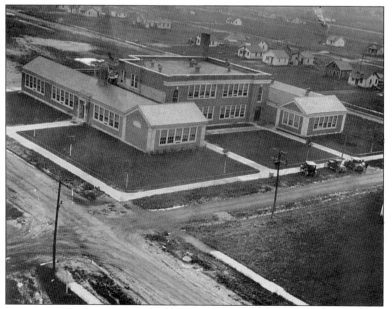

In 1922, Angell Elementary School was built on Bacon Avenue between Beverly Avenue and Wiltshire Road. The school was named for James B. Angell, who had been president of the University of Michigan. Minnie Green was the first principal. Today, Angell is the oldest school in Oakland County.

This winter scene shows Berkley School in 1956. The ground has been cleared for the construction of Berkley High School. The original plan called for Berkley High to be built in Southfield on Greenfield Road, where the Oakland County Health Department now stands. It was to include grades 10 through 12. There was a public outcry about locating the school outside Berkley, and the Southfield land was sold. (Courtesy of Maybelle Fraser.)

A flyer distributed by the Berkley School District when Oxford School opened in 1951 called it "a new era for schools." The first principal was Neva Schalm, who served from 1951 to 1961. When the population began to decline in the 1980s, Oxford School was closed, and since then houses have been built on the property.

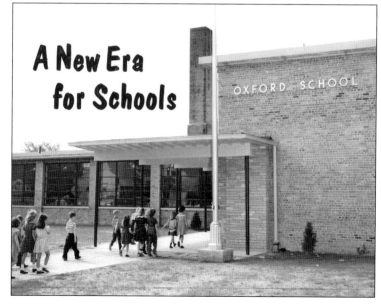

This is the sad ending for Oxford School. Boarded up, it awaits the wrecking ball. As the city's population declined, beginning in the early 1980s, Oxford was the first of Berkley's schools to close. The last principal was Glenn Dawson. (Courtesy of Berkley School District.)

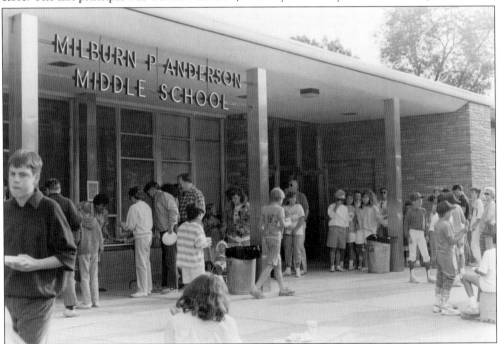

Milburn P. Anderson Middle School opened in 1956 to provide education for sixth through eighth grades. Until then, students attended kindergarten through eighth grade at elementary schools. Walfred Kuijals was Anderson's principal for its first 10 years. (Courtesy of Berkley School District.)

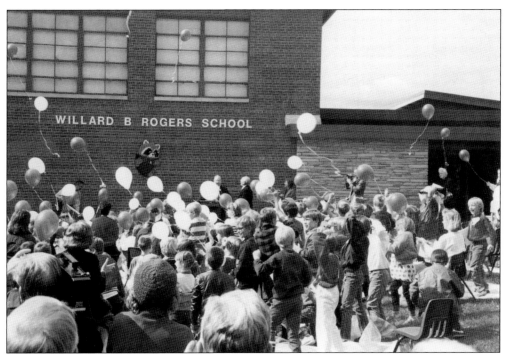

Hamilton Elementary School opened in 1952 on Hamilton Avenue at the foot of Larkmoor Boulevard. When the beloved principal retired, the school was renamed the Willard B. Rogers School in his honor. Here, the crowd is celebrating the event. Rogers can be seen under the letter *c* in "School."

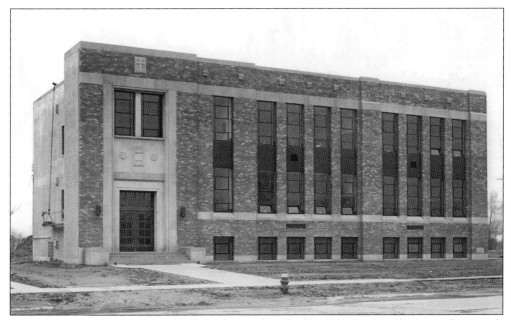

Only the north wing of Our Lady of LaSalette School had been built when this 1946 photograph was taken. There were 325 pupils that year. In 1943, the first two classes had opened in the basement of the church. In 1953, the south wing was opened to complete the building.

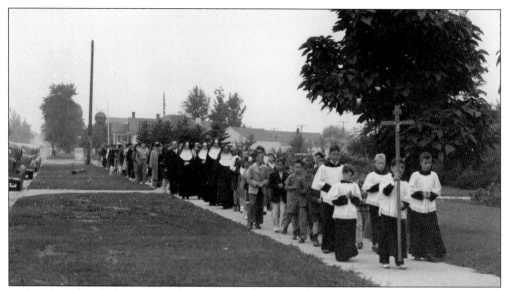

A common sight for decades was parades of schoolchildren led by the Sisters of Mercy during religious and school events. For four decades, the Sisters of Mercy taught at Our Lady of LaSalette Grade School on Coolidge Highway. They lived next door in the slate-roofed convent. (Courtesy of Our Lady of LaSalette Church.)

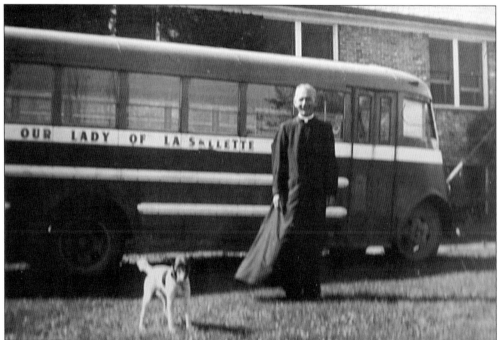

Here, Fr. Laval L. Landry (1900–1998) stands next to Our Lady of LaSalette's school bus. Father Landry took over the parish in 1932 and basically built it from scratch. He drove the bus himself and would even pick up public school students and drop them off at their schools. He was considered quite progressive. For years, Our Lady of LaSalette School was one of only two Catholic schools that were members of the National Parent Teacher Association. (Courtesy of Our Lady of LaSalette Church.)

Six Sisters of Mercy stand in front of Our Lady of LaSalette School in 1958. Their habits were very distinct, marked by a leather cincture around their waists with a black rosary hanging from it. They were always seen in Berkley in pairs. For many years, there were enough Sisters of Mercy to teach all the classes, but as their numbers declined, lay teachers were hired. (Courtesy of Our Lady of LaSalette Church.)

Coach Pat Fox led the Berkley High School football team to their best year ever in 1994. The team's star, Aric Morris, later became captain of the Michigan State University football team and then played for the Tennessee Titans. He is no. 33 in the third row. (Courtesy of Pat Fox.)

In 1949, when Berkley High School opened on Catalpa Drive, few people could have predicted what a group of pranksters would be attending. Every year, seniors tried to outdo each other, but 1971 was the year that has proven unbeatable. Note the Volkswagen on top of the school in this photograph; seniors put the car there and hung a graduation tassel from it.

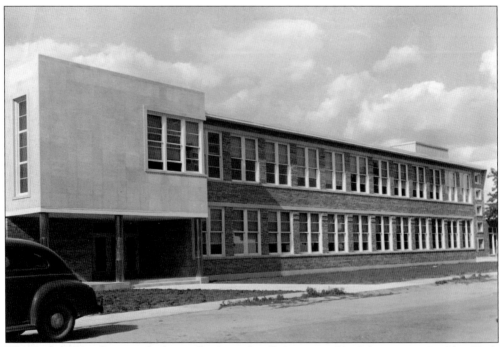

This early-1950s photograph shows the Sunnyknoll Avenue side of the present Berkley High School. The first class graduated in 1927 from the earlier school, which had been located across the street. Among the prominent alumni are actor Curtis Armstrong, who played "Booger" in *Revenge of the Nerds*; local television anchorman Bill Bonds; NBA player Bruce Flowers; Boston Red Sox pitcher Dick Radatz; and the notable animal rights activist Gary Yourofsky.

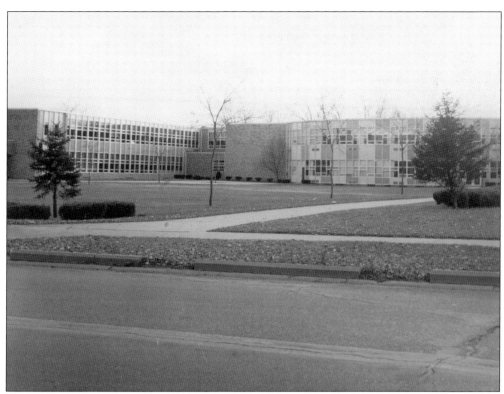

The original 1949 Berkley High School building has seen three additions. This photograph shows the middle additions as of 1975. Later, an auditorium was added to the east wing. Two Berkley High School principals later had school buildings named after them: Milburn Anderson (1929–1939) and Charles Avery (1948–1952).

In 1957, under the direction of James Bradner, Berkley High School's science teacher, the students built the largest cyclotron in any high school in the United States. It was housed across the street in the basement of the old Berkley Elementary School. Berkley High School took great pride in being a leader in science education.

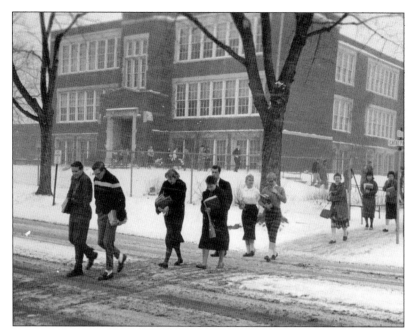

For several years after Berkley High School opened on Catalpa Drive, students often had classes both there and in the older building across the street. Students often trudged through the slush from one building to the other.

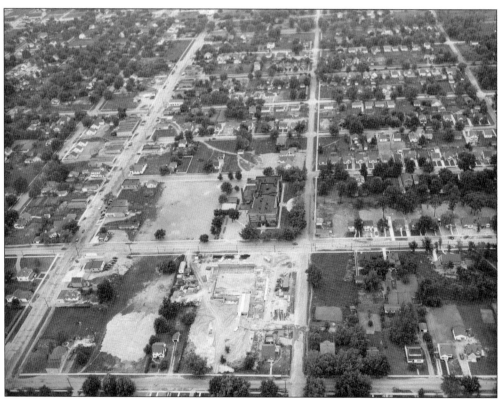

This early-1950s aerial photograph looks down on the Coolidge Highway and Catalpa Drive area where the ground has been cleared to construct Berkley High School. Berkley Elementary School still stands on the north side of Catalpa.

Six

Religious Life in Berkley
A Heritage of Spirituality

The first settlers in Berkley primarily came from New York and New Jersey and were of Scots Irish and Pennsylvania Dutch extraction. They brought their religions with them. Many of the first families were Presbyterian, but they were quickly followed by members of the Congregation, Baptist, and Methodist religions.

For years, there were too few settlers to support a church in Berkley, so the first families made the trek to Royal Oak on Sundays to attend services. In addition, some families held church services in their own homes. One such example was the services James Hickey held in his farmhouse. A devout Methodist and a lay minister, Hickey preached that the world was flat. In the early 1900s, revivalists would set up tents and hold services.

By the 1920s, Berkley's population had grown enough to support its own churches. In rapid order, the major religions formed congregations. In almost every case, they began by meeting in homes or stores and then built their own houses of worship. An early Baptist Church was built on Coolidge Highway and Dorothea Road, but it later merged with a group in Royal Oak. In 1920, Berkley Community Church opened at Wiltshire Road and Kipling Avenue. A year later, Our Lady of Refuge Catholic Mission opened on Catalpa Drive, later renamed Our Lady of LaSalette. Trinity Lutheran Church was founded in 1923 on Royal Avenue and was followed two years later by the opening of Christian Missionary Alliance Radio Temple on Twelve Mile Road. The Methodist Church was founded in 1929 in the same year the Church of Christ opened in a cobblestone building on Twelve Mile. Gethsemene Lutheran Church (1943) and Greenfield Presbyterian (1949) were relative latecomers to Berkley.

Most of these churches rapidly outgrew their original structures and built new ones. Some of them lost members and sold their buildings to new congregations; however, most of these groups continue to thrive in Berkley and have been joined by newer denominations. Berkley's family-oriented identity is mirrored in its active religious life.

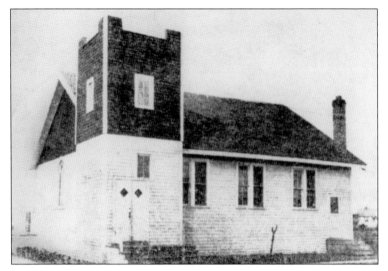

The first church erected in Berkley was this wooden First Baptist Church, which stood on the east side of Coolidge Highway at Dorothea Road. It was built in 1920. The parishioners eventually merged with another Baptist congregation in Royal Oak. This charming church was painted white and green.

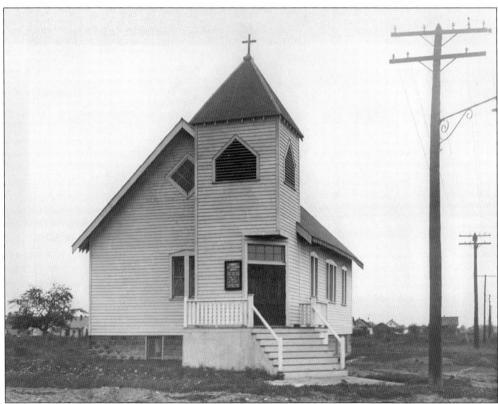

In 1923, the newly ordained minister, Harry Holst Dinsen, was sent to establish a Lutheran church in the village of Berkley. After services were held at a variety of locations, this church, named Trinity Lutheran, was built on the corner of Royal and Beverly Avenues for $3,500. The first services were held there on May 17, 1925. In 1927, the congregation was officially accepted in the Missouri Synod of the Lutheran Church. (Courtesy of the Walter P. Reuther Library Archives.)

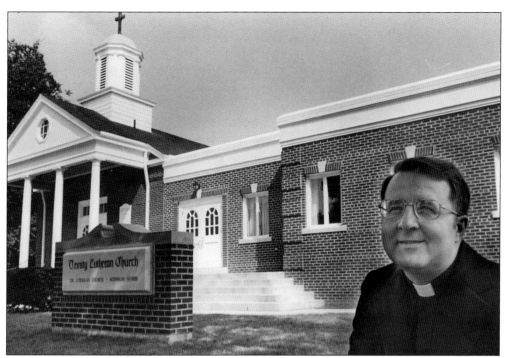

The congregation of Trinity Lutheran Church grew rapidly in the 1940s. On October 2, 1949, they broke ground for a new church next to the older building on Royal Avenue, constructed at a cost of $66,301. The former church was sold and moved to Wayne, Michigan. Rev. Edward Jankers, who served as pastor from 1958 to 1971, is seen here with church. Membership began to decline in the 1990s, and the church was dissolved. The building is now occupied by St. Mary's Antiochian Orthodox Christian Church.

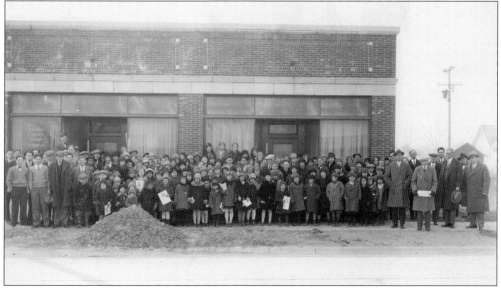

This 1929 photograph shows the first anniversary celebration of Berkley's First United Methodist Church. The church later moved out of these storefronts into a new building at Twelve Mile Road and Kipling Avenue. (Courtesy of the First United Methodist Church.)

On January 18, 1929, the Reverend E.J. Warren held a meeting in a building on the corner of Twelve Mile Road and Berkley Street to found the First United Methodist Church of Berkley. On March 6, Rev. J. Rayle became its first permanent pastor, and the church began to grow rapidly. The congregation moved into a building near Twelve Mile and Coolidge Highway but sold it a few years later to Roseland Park Cemetery. For $5,000, the congregation bought the land on the corner of Kipling Avenue and Twelve Mile to build the church still in use today. One interesting detail about this photograph of the congregation's first church is that the street sign shows the old name for Twelve Mile Road, Oakwood Avenue. (Courtesy of the First United Methodist Church.)

The congregation of the First United Methodist Church grew rapidly though the 1940s and 1950s. They soon outgrew their older building, and on May 30, 1954, they broke ground on the new sanctuary that was to be added to the existing structure. They borrowed the money from the Home Mission Board of the Methodist Church, and in 1962 they were able to pay off the loan.

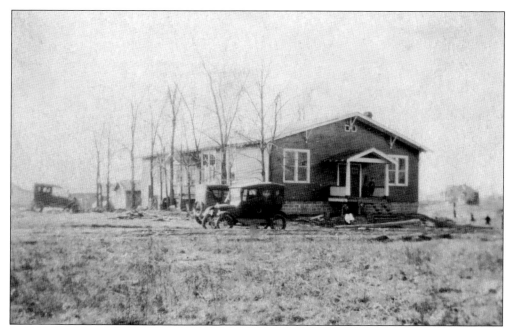

In 1929, Rev. Van Loon bought the temporary school building that had stood on Catalpa Drive and moved it to the corner of Kipling Avenue and Wiltshire Road to found the Berkley Community Church. This photograph shows that not much else occupied that area. Van Loon was a dynamic and popular speaker, and the congregation rapidly grew. Over the years, the church has added onto the building several times, but this structure still forms a part of the current building.

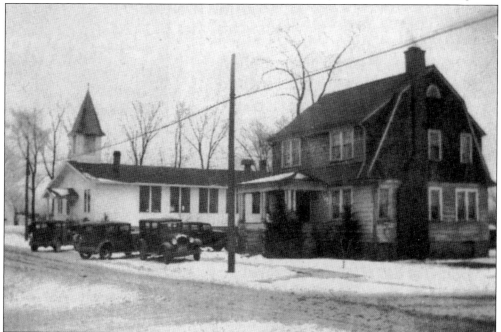

By 1929, when this photograph was taken, the Berkley Community Church had become the largest church in Berkley. The original building had already been added to once, and a handsome home for the pastor had been erected.

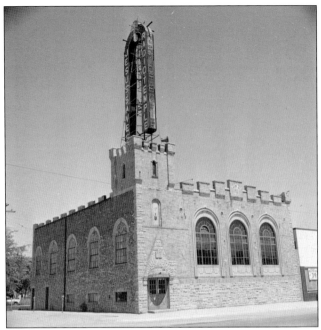

In 1922, Rev. Ed Weinzerl came to Berkley and set up a missionary tent. Five hundred people flocked to his services. In 1932, he built this church on the corner of Gardner Avenue and Twelve Mile Road and named it the Christian Missionary Alliance Radio Temple. Radio station WEXL carried the services live. Over the years, the congregation shrank, and the building was sold to the Greek Orthodox Church and was renamed St. Mary's Orthodox Church. (Courtesy of the Walter P. Reuther Library Archives.)

In 1955, the Raven Brethren erected this church on the corner of Eleven Mile and Stanford Roads. The Raven Brethren were an offshoot of the Amish. For years, they could be seen walking around Berkley in their grey and black outfits. They outgrew the building in 1981 and sold it to the Restoration Bible Church, which had started in Royal Oak. When a driveway was constructed in the 1990s, workers unearthed an old stone bridge that had been used to cross one of the many creeks that formerly existed in Berkley. (Courtesy of J.S. Brooks.)

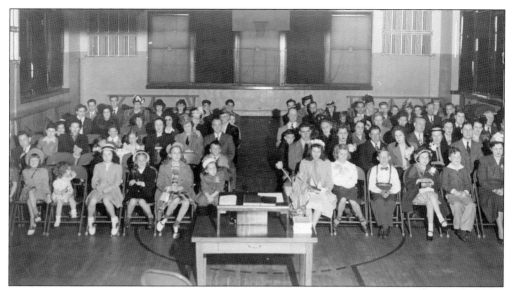

Here is the congregation of Berkley's Presbyterian Mission on March 28, 1948. During this period, they were meeting in Angell School. Several of the Berkley churches used to meet in schools or empty stores until they could build their own churches. (Courtesy of Greenfield Presbyterian Church.)

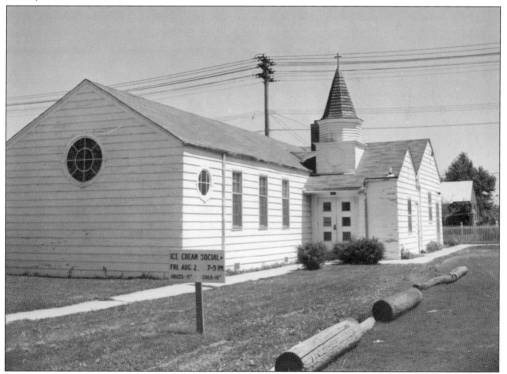

Presbyterians first held their services in Angell Elementary School. The first pastor was Charles Leber, who was soon followed by Rev. Charles Bates. Under Bates's leadership, the congregation grew rapidly, and in 1949 they moved into this white frame church at Catalpa Drive and Greenfield Road. They borrowed $15,000 to acquire the building.

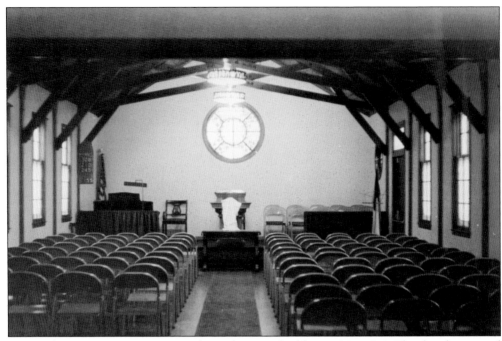

The Presbyterian congregation moved into their own building in May 1949. The church, pictured here, had 79 charter members. (Courtesy of Greenfield Presbyterian Church.)

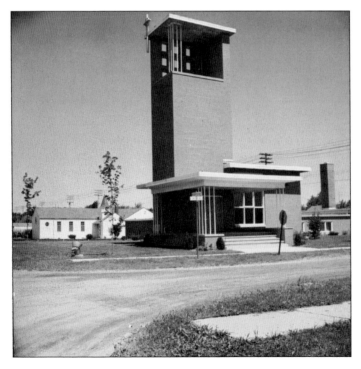

On October 1, 1954, the cornerstone of the new Presbyterian Church was laid. The building was not completed until 1958, when worship services could finally be held in the new sanctuary. The original white frame church can be seen standing next door. For years, the older building was used for Sunday school and a church hall. (Courtesy of the Walter P. Reuther Library Archives.)

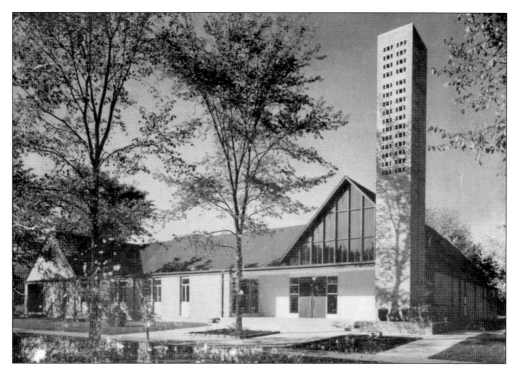

After having met for years in rented facilities, Gethsemane Lutheran Church built this handsome building at 2119 Catalpa Drive next door to Berkley High School. In May 1980, the church merged with St. Peter's Danish Lutheran Church of Detroit. Rev. John Northcott was the pastor at the time and guided the marriage of the two communities. (Courtesy of Cana Lutheran Church.)

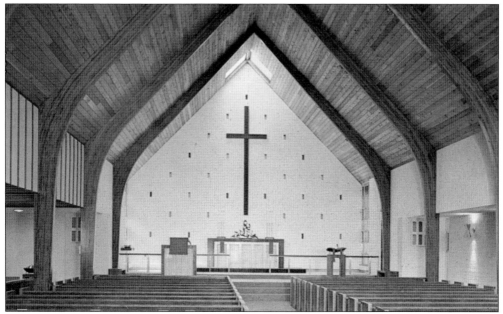

This is the inside of Cana Lutheran Church on Catalpa Drive in 1959; little has changed since then. The church is noted for its beautiful wood ceiling and wonderful acoustics. (Courtesy of Cana Lutheran Church.)

The Church of the King stands on the northwest corner of Twelve Mile Road and Phillips Avenue. It was founded as the Berkley Assembly of God in a storefront on Twelve Mile by Pastor Tyler. For many years, this building consisted of just the basement until the upstairs was added in 1957. Notice the sign for Krazy Kelly's Furniture and Appliance Store on the building next door. It was a prominent Berkley business during the 1960s. (Courtesy of Church of the King.)

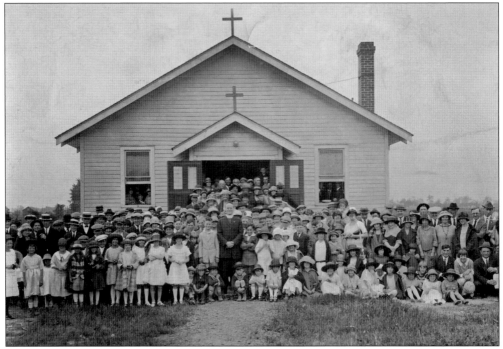

Our Lady of Refuge Catholic Church stood where the tennis courts next to Anderson Middle School are now located. The church occupied five acres of land. The parish traded the land for property on Coolidge Highway, and the LaSalette Fathers and missionaries took possession in 1933.

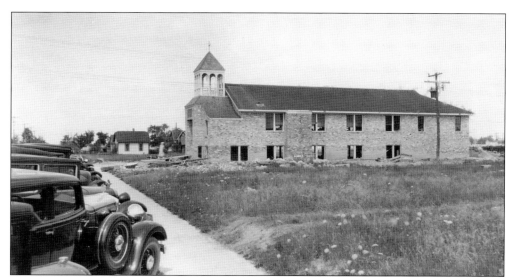

This is the exterior of Our Lady of Refuge Catholic Church after it was moved to Harvard Road. The photograph shows bricks being added to the structure. The bell tower was also added after the move. Volunteers did all of the work, including digging the basement that was used as a church hall. In 1932, when the LaSalette missionaries took over the church, they discovered that there was not even enough money to turn on the electricity.

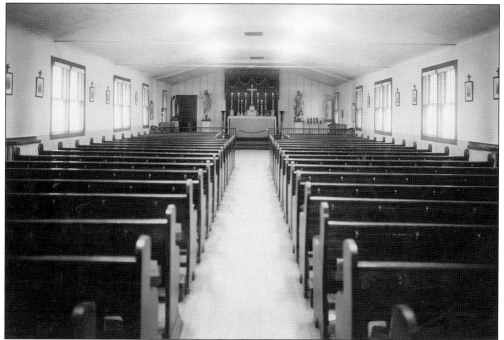

This photograph shows the interior of Our Lady of Refuge Church in the 1930s. The building originally stood on Catalpa Drive next to the current site of Anderson Middle School. In 1927, it was moved to Harvard Road. The congregation outgrew this building and temporarily moved services into the basement of what is now the Fr. Landry Center. Thereafter, this room was used for a variety of purposes, including dance instruction for students. The nuns made sure no one danced too close.

This beautiful Tudor Revival building was erected in 1927 by Our Lady of LaSalette Church at a cost of $27,763.67. It was first a rectory and later a convent before being sold and moved to make way for the new church in 1958. It later became a gift shop and then offices. Efforts to sell and move the building for a second time failed, and it was demolished in 2005.

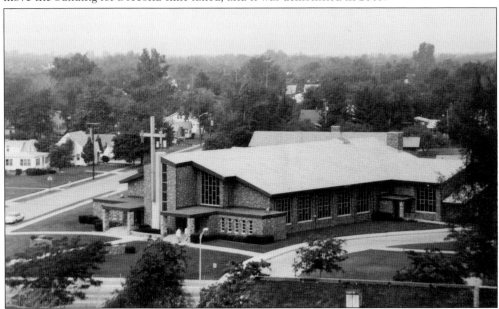

This is the fourth church used by the Catholic community in Berkley. Construction began in 1966 at a cost of $54,000. In 1967, the completed building was dedicated. In 2005, the congregation of Our Lady of LaSalette observed the church's 80th anniversary with a special Mass celebrated by Cardinal Adam Maida.

Seven

BERKLEY CELEBRATES
PARADES AND EVENTS

In 1926, a competition was held to rename Monnier Road when it was extended from Twelve Mile Road to Woodward Avenue. The winning entry was Coolidge Highway in honor of the current president. The Independent Order of Odd Fellows decided to mark the occasion with a parade and festival, thus Berkley Days began.

Berkley Days was suspended in the late 1920s and early 1930s because of the Depression, but it was resumed in 1936 and has been held in the spring ever since; however, financial hardships forced the end of the parade in 2001. The festival features carnival rides, dog contests, horseshoe competition, races, a craft fair, raffles, and lots of food. The annual celebration attracts thousands of visitors from all over the Metro Detroit area.

In 1960, the first Christmas Parade was held and became an annual tradition. It is now called the Holiday Lights Parade. Santa Claus always makes an appearance, and some years he even arrived via helicopter.

The city also held a popular ice show at the ice arena in the spring. Premiering in 1977, the show featured the talents of skaters from the Berkley Royal Blades Figure Skating Club and the city's Learn to Skate program. The show was yet another victim of budget constraints, and the last show, fittingly named Legends on Ice, was held in 2010.

Two of the biggest events that Berkley has celebrated have been the end of World War II and the country's bicentennial anniversary. When World War II ended in 1945, the city held a parade; horns and whistles blasted, and an effigy of the Japanese emperor was hung in front of city hall. The bicentennial was honored with a parade, speeches, and a city picnic attended by hundreds of citizens.

Starting in 1995, Berkley's biggest event has been the annual Woodward Dream Cruise. Over 40,000 classic cars cruise the area, and over a million people line Woodward Avenue to enjoy them. Berkley's contribution is the Friday night CruiseFest classic car parade on Twelve Mile. Thousands of people line up early for the best viewing spots.

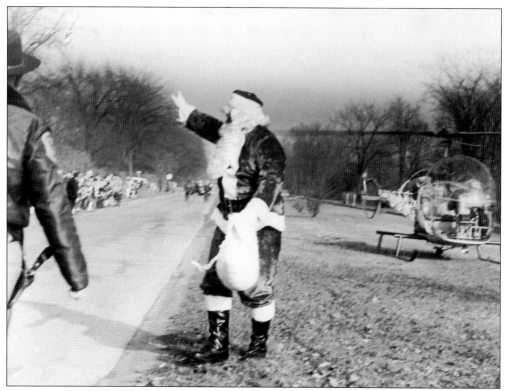

In the late 1960s, Santa must have had some labor trouble with the reindeer since he had to helicopter himself in. Officer John P. Wolff was Berkley's Santa for most of those years. The Berkley Christmas Parade was first held in 1960 and had been a regular civic event. Due to financial problems, the city could no longer afford to continue funding the parade. Subsequently, a citizens group resurrected the event, and it is now called the Holiday Lights Parade.

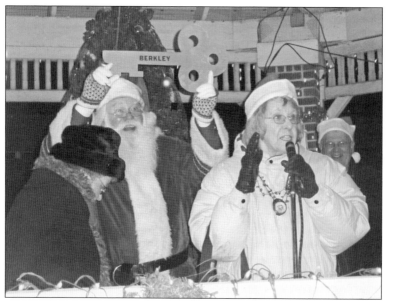

One of the main uses of Berkley's gazebo every year is to have a place where Santa Claus can hear the wish list of Berkley's children. Here, he has been given the key to the city by Mayor Marilyn Stephan, who led Berkley from 2005 to 2011.

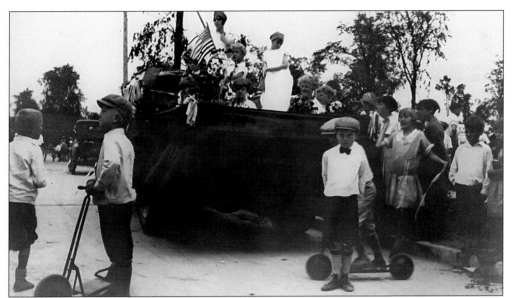

Here is another photograph from an early Berkley Days parade. The children are getting ready to join the parade on their scooters right behind the Berkley Women's Club float.

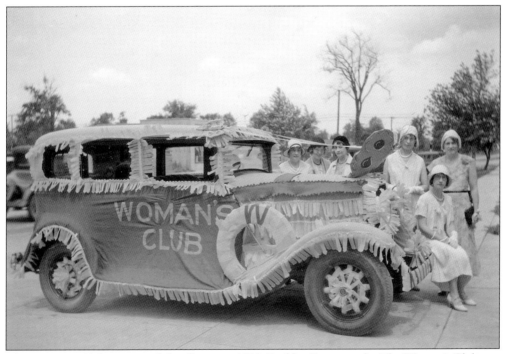

The Women's Club sponsored this float in a 1920s Berkley Days parade. The Women's Club was founded by Mrs. A.J. Hurton in 1922 to provide social activities for Berkley's women. Most women during this period stayed home, and because many had neither cars nor phones, they were anxious to do something outside the house. The Women's Club held dances, plays, and charity drives. It also established Berkley's first library in the then-new city hall.

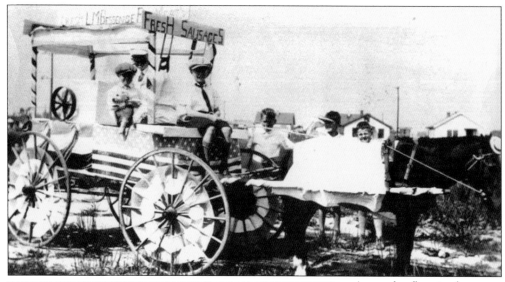

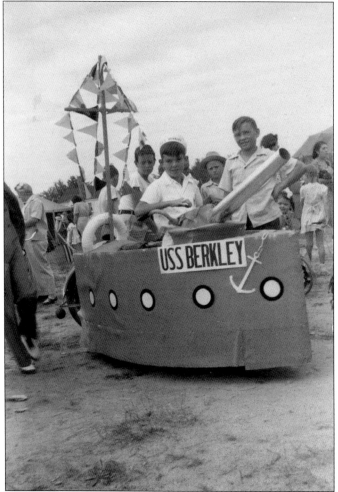

A popular float in the Berkley Days Parade was this one sponsored by Bessinger's Market. Spectators were delighted by the sight of a small dog being placed in a box, and then sausages would emerge from the other side. The float was the talk of the town for years.

Here is a very patriotic float from the 1943 Berkley Days parade. During World War II, many of the floats took on a military flavor. The "captain" on the boat is Russ Murphy, who was involved in many Berkley groups over the next six decades. His two Detroit cousins are with him. (Courtesy of R. Murphy.)

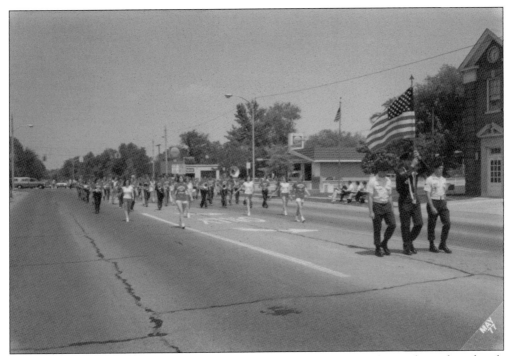

For over 20 years, Berkley Days was opened with a parade. Here, one of several marching bands can be seen in the 1977 parade. Children would ride their specially decorated bikes in the parade and show off homemade floats. Prizes were handed out in several categories.

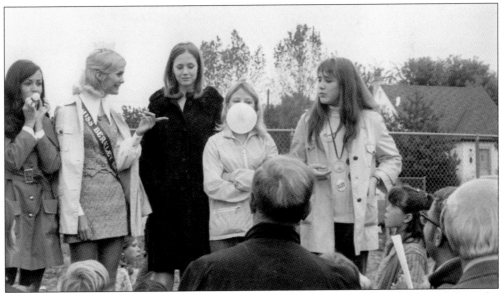

Over the years, Berkley Days grew to include more and more events. This photograph from the 1971 festival represents two events that year. The second young woman from the left, wearing her Miss Berkley ribbon from an earlier competition, watches while girls compete in the bubble-blowing contest.

Berkley Days offers a lot more than just carnival rides and contests. All kinds of community groups and artists set up booths in the ice arena. Here, Steve Baker (left) and Neil and Carol Ring man the booth for the Berkley Historical Committee in 2008. Carol was a founding member of the group and for many years served as its chairperson.

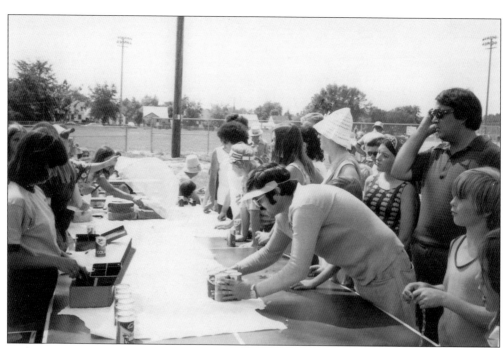

Berkley went all out to celebrate America's bicentennial in 1976. Parades, speeches, and all kinds of activities took place. Hundreds of people came out for the picnic pictured here. One lasting monument to the event was the creation of the Berkley Historical Committee, which was formed to preserve the city's history. This step led directly to the creation of the Berkley Historical Museum.

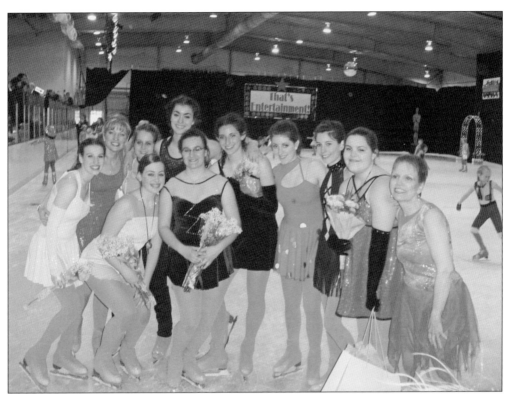

Assembled on the last day of the 32nd Berkley Ice Show, held in 2008, are some of the participants. From left to right are (first row) Emily Griswold and Megan Bauer; (second row) Eryn Fox, Lisa Bradley, Meghan Steingold, Rachel Dickerman, Michelle Lapin, Tara Fugate, Zoe Grossfeld, Marti Engman, and Sue Richardson. The city curtailed the popular show after the performances in 2010 due to budgetary constraints.

On the third Saturday in August, the Woodward Dream Cruise is held. Berkley kicks off the event the evening before with a parade of classic cars on Twelve Mile Road. Here, people have lined Twelve Mile to watch the parade. The Woodward Dream Cruise is the world's largest automotive event with an estimated 1.5 million people attending every year from across the country and around the world.

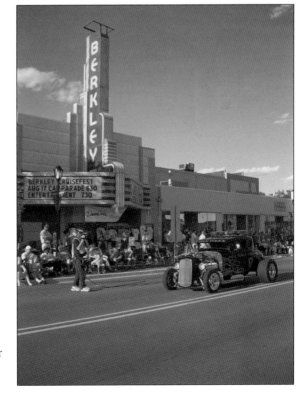

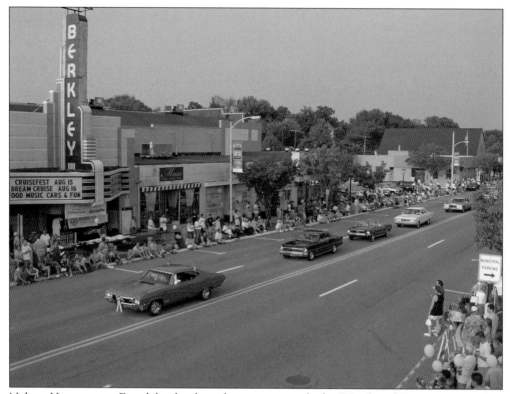

Nelson House was a Ferndale plumber who came up with the Woodward Dream Cruise idea. His sole aim was to raise enough money to build a children's soccer field. The first cruise was held in 1995, and promoters hoped 30,000 people would attend. That expectation was exceeded when 250,000 showed up. Here is a line of vintage cars passing the Berkley Theater in the city's CruiseFest classic car parade held the evening before the Woodward Dream Cruise.

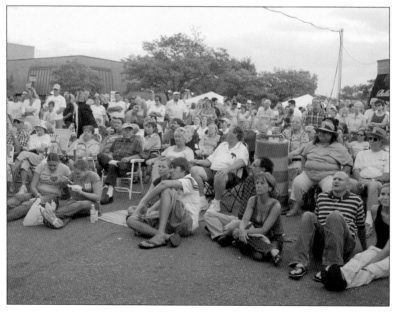

Spectators from all over lined up at least 11 people deep to watch the Friday night CruiseFest classic car parade on Twelve Mile Road in 2006. This event has become one of the most popular Woodward Dream Cruise events and has steadily grown in popularity.

Eight

MUNICIPAL OFFICES
AND PUBLIC SAFETY
SERVING THE COMMUNITY

Until 1923, Berkley was part of Royal Oak Township. Becoming a village on April 6 meant creating agencies for police, fire, water, and administration. The newly elected village commission appointed the president, clerk, treasurer, attorney, assessor, head of highways, and police chief. In 1924, *The Detroit News* described Berkley as a "frontier community which resembles a settlement in the oil waste of Wyoming." Nevertheless, the village was off and running.

The village's first purchase was a tractor to haul cars to and from Woodward Avenue because the roads leading to Woodward were often impassable. The government faced many problems from the beginning. In 1924, the first fire truck was purchased but burned up in a shed the same year; legend has it that a fireman threw a cigarette into a bucket of flammable liquid he mistook for water. In 1925, the village bought another fire truck, but the following year it was destroyed when the fire station was engulfed in flames.

The police department grew slowly to meet the village's needs. Residents were proud when the fledgling force grew from two officers to four in 1924. Now, there could be someone on duty 24 hours a day.

In 1927, the Berkley Department of Public Works drilled down 219 feet, and Berkley had a well. Soon, the department added a 150,000-gallon water tank. Sidewalks and paved streets quickly followed. Berkley had all of the modern conveniences.

Village offices were located in a white frame building on the corner of Coolidge Highway and Twelve Mile Road until a new building was erected in 1928. That two-story brick facility housed the village offices, city council, and police and fire departments. In 1983, the police and fire departments merged to become public safety, and in 1989 it moved to the Frank W. Irons Public Safety Building. The old fire hall today proudly houses the Berkley Historical Museum.

Major changes in Berkley's government happened in 1932, when Berkley became a city, and in 1944, when the manager-council form of government was adopted. The first female city manager, Jane Bias-DiSessa, was hired in 2001. Berkley was now a modern city.

Berkley's 1923 village officials are certainly a distinguished looking group. From left to right are (first row) James F. Heald, C. Arthur Dunston, and Stephen E. Hurd; (second row) Thomas C. MacKenzie, Louis G. Bessinger, Lois M. Adix, Earl E. Phelps, and Asa V. Kelley. Dunston was Berkley's first mayor and also the first owner of the Northwood Inn.

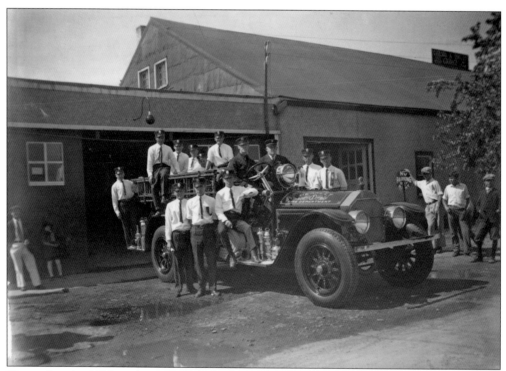

Pictured in the 1920s is the original fire station. When it ironically burned down, an electrical company allowed the department to store its equipment there for free. This lasted until the new combined city hall and fire station was opened in 1928. Chief Frank Irons is pictured on the right side of the truck near the front.

110

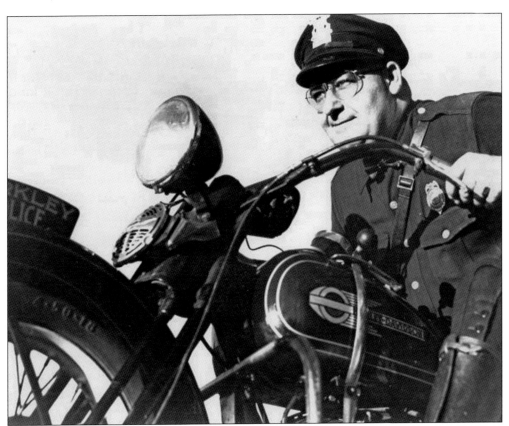

One of Berkley's most beloved police officers was John P. Wolff, shown here on his cherished police motorcycle. When he joined the force in 1935, during Prohibition, his first job was to raid a local bar nicknamed the "Bucket of Blood." He rose to assistant chief before he retired. For years, he was Berkley's Santa Claus during the Christmas Parade. (Courtesy of Donna Sayers.)

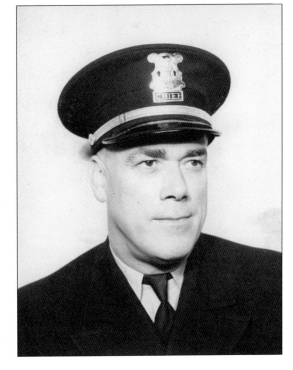

When police chief Peter P. Sykes retired in 1967, few in Berkley could remember a time when he was not their chief. Allen L. McCabe had been Berkley's first chief of police. Sykes (pictured) was replaced by William M. Lennox, who had previously served with the Oak Park Police Department.

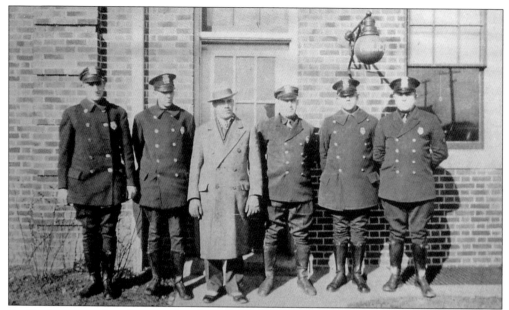

Berkley's motorcycle police stand with Chief Frank Irons (in overcoat). Police used motorcycles because they were cheaper to operate during the Depression. Berkley was the first city in Oakland County to have its own jail, located in the city hall-fire station on Coolidge Highway. It housed two jail cells.

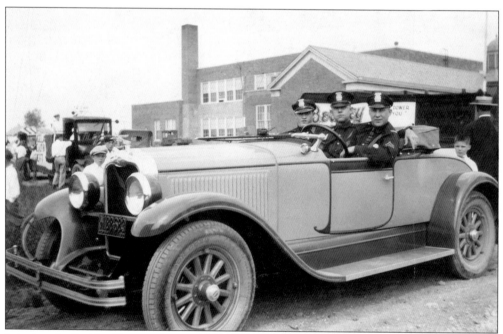

It is time for Berkley Days in August 1927. The first festival was held in 1926, and it took place in a variety of locations over the years, but in 1927 it was held behind Angell School. Berkley police officers are pictured ready to take their place in the parade in their 1926 Ford. The car sports steel bands and wooden spokes on the wheels.

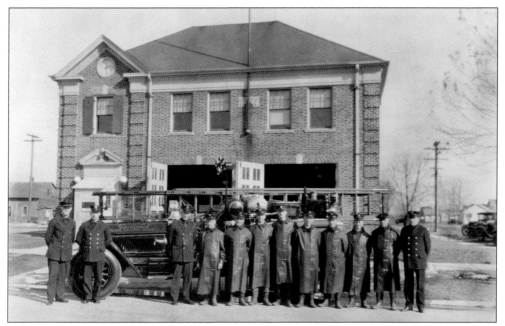

This photograph was taken during the dedication of the new fire hall and village office building on March 8, 1928. Shortly after this, the crew had to leave the ceremony to respond to a fire alarm. It proved to be a false alarm, and they soon returned. The building was designated a historic site by the State of Michigan on July 21, 1988.

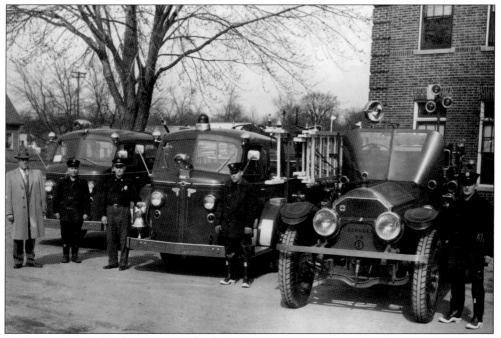

Frank Irons (far left), the youngest chief of police in Michigan, stands with the volunteer fire department and their fire trucks. From left to right are a 1953 American LaFrance, a 1951 American LaFrance, and a 1926 American LaFrance. The LaFrance Company made the first modern fire trucks in America and continues to produce them.

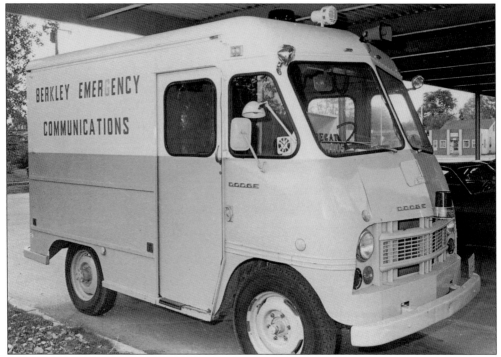

The Berkley Emergency Communications Truck (commonly called the BCAT) was a familiar sight in Berkley from the late 1950s to the 1980s. Manned by volunteers, it provided emergency services at all activities that drew a crowd, such as high school football games and the Christmas parade. The crew could summon ambulances, fire trucks, and police if necessary.

Fireman Larry Harrison slides down the pole in the old firehouse on Coolidge Highway. Harrison served as a Berkley fireman from 1964 to 1991. This response to an alarm always looks like fun, but it could be dangerous. Lt. Ed Henning broke his leg, and "Shorty" Schneider lost an ear. The pole now resides in the Berkley Historical Museum.

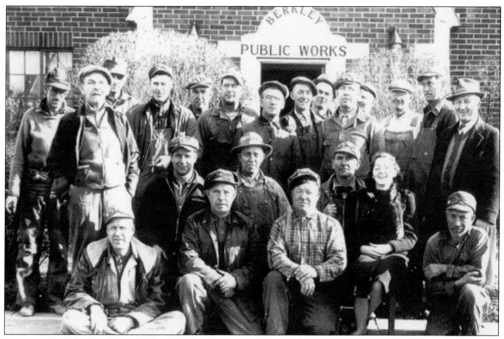

The staff of the Berkley Public Works Department stands in front of the new headquarters on Bacon Avenue in the late 1930s. From left to right are (first row) Frank Johnson, John Chapman, Stan Baruk, Eve Archibald, and unidentified; (second row) R. Rose, C. Wirick, and Clem Mumper; (third row) Charles Durham, Earl Humphrey, Allie Trudell, John Collins, Ernie Carlson, Walter Stegena, Eddie Grace, and Joe Fons; (fourth row) Leonard Brown, Lewis Fowler, J. Stencil, Fred Fairbrothers, E. Collins, and Mr. Clark.

Berkley firemen have always had the latest in fire equipment. Here, they welcome a new fire truck in the early 1950s. Sitting in the truck is Lt. Ben Weston, while Chief Robert Hannah perches on the truck by the ladder. Standing by the truck are police chief Frank Irons (left) and Harland Bullard.

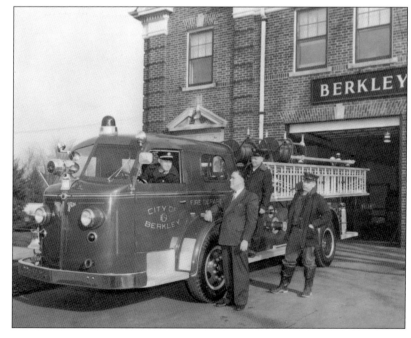

Maybelle Fraser became Berkley's first female mayor in 1995. Here, she stands in the middle of that year's city council. From left to right are Charles Lowther (city attorney), Angus McPherson (council member), John Mooney (council member and future mayor), Violet Baldwin (council member), Fraser, Anthony Agbay (council member), Daniel Benton (council member), Ronald Meyer (council member), Lee Garrett (city clerk), and Bill Rechlin (city manager).

In 1967, Berkley police formed the Berkley Police Officers Association to bargain with the city. Chris Flynn was elected the first president. Here, off-duty police officers are picketing for a higher salary. The dispute was finally settled by arbitration, and police officers with three years of experience were given a top salary of $12,000.

116

The village hall, constructed in 1928 at Coolidge Highway and Rosemont Road, eventually proved too small to house all of the city offices, including fire and police departments. In 1958, the new city hall was added onto the older building. The building is seen here under construction. The police and fire departments remained in the older building until a new public safety structure opened in 1989. (Courtesy of the Walter P. Reuther Library Archives.)

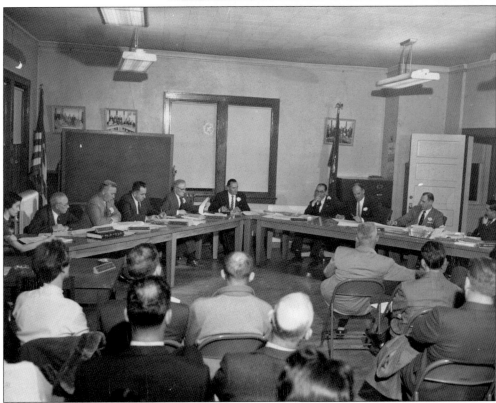

The Berkley City Council met on the second floor of city hall starting in 1928. This photograph shows the 1957 council.

As part of the nation's bicentennial, the Berkley Historical Committee was formed to collect and preserve Berkley's history. Here, members of the original committee meet to plan the museum that is now located in the old firehouse. From left to right are Shirley McLellan (chair), James Jeffrey Tong, William Ackerman, Ralph Conklin (later on the city council and mayor pro tem), and Maria Ward.

In 2011, the 34th Berkley City Council was elected. Under its leadership, Berkley continues to make history. From left to right are Jack Blanchard, Eileen Steadman, Steven W. Baker, Dr. Phil O'Dwyer (mayor), Dan Terbrack, Lisa Platt Auensen, Alan H. Kideckel, and Jane Bais-DiSessa (city manager).

Nine

ROSELAND PARK CEMETERY
HONORING THE DEPARTED

From farmland to final resting place, Roseland Park Cemetery in many ways is intricately entwined with the history of Berkley. The land on which the cemetery now sits was originally farmed by Native American tribes for corn and squash. In the mid-1800s, John Benjamin and his son John Jr. purchased the land and erected a two-story structure in which they produced the Benjamin Muley Grain Cradle. This device, combining the sickle with a cradle to separate wheat from the chaff, enabled farmers to quadruple their yield.

In 1906, a group of forward-thinking businessmen who anticipated population expansion northward from Detroit founded Roseland Park Cemetery. A stock purchase converted the north section of the Cromie Dairy Farm on Twelve Mile Road from cattle pasture to graveyard.

Although John Tuttle was the first person buried here in 1908, Roseland Park was officially dedicated in June of 1910. More than 1,000 people attended, including the mayors of Detroit and Pontiac. Poet Edgar Guest read a poem he had written for the ceremony.

From its modest one-acre beginning, the cemetery gradually expanded to its current 135 acres. During the Depression, though, the cemetery sold a portion of its land to a developer who created the St. Johns Woods subdivision.

Many noteworthy people are buried here, including two former Detroit mayors, Frank Doremus (also a member of Congress) and Philip Breitmeyer; Fred Goldsmith, who invented the curveball but is said to have died of a broken heart when that honor was granted to another player in the National Baseball Hall of Fame; David "Davey" Jefferson Jones, a Detroit Tiger from 1901 to 1915 and a teammate of Ty Cobb; Rob Tyner, the lead singer of the rock group MC5; and Amy Ross, head of the employment bureau of the Veterans of Foreign Wars, who provided aid to World War I veterans and their families and was buried with full military honors—the first time for a woman. Contrary to legend, Arthur Godfrey is not interred in Roseland Park. Although he was a salesman for the cemetery before becoming a famous entertainer, he is actually buried in Florida.

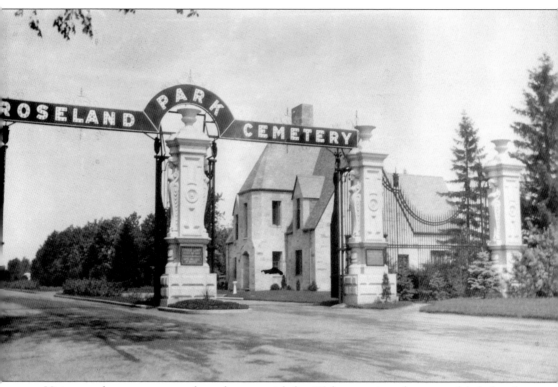

Visitors to the cemetery pass through a gate with five 25-foot granite columns modeled after those found at Mussolini's palace. Each column was sculpted from 250 tons of white Barre granite. The distance between the pillars was purposely designed to accommodate four teams of horses, and the double driveway prevented congestion.

Located just inside the gate is the building originally established as the park superintendent's home. The structure was acquired from a 1927 Sears, Roebuck, and Co. catalog. In time, it was converted into a sales office and today serves that function as well as providing additional office space.

Just inside the gates is the impressive building that serves as the main office and sales building for the cemetery.

Dubbed Lake Berkley, this artificial pond once attracted not only wildlife, but also human spectators who would feed the ducks and geese. In addition, the pond provided a habitat for foxes, raccoons, squirrels, turtles, quail, and pheasants, thus earning the cemetery the designation of a national wildlife sanctuary by the Michigan Department of Natural Resources; however, concerns about bird flu led to the decision to fill in the pond in 2006.

The cemetery was once famous for its profusion of red, white, and pink rambler roses, especially on the eastern border by Woodward Avenue. In fact, the distinctive bushes led to the cemetery's name. The roses have since been removed.

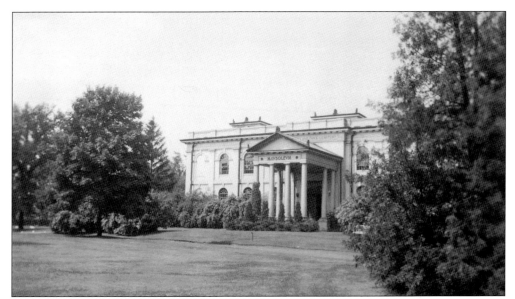

The Rose Chapel Mausoleum, dedicated on October 18, 1914, was the largest such public structure in the country and the first mausoleum in the Detroit area. The materials were transported to the site by horse-drawn wagons. The designer, Detroit architect Louis Kamper, was inspired by European mausoleums, which he had studied for two years. The structure's magnificent Doric columns give it the appearance of an English country manor. The mausoleum holds 1,300 crypts, and Kamper himself is buried there. In 1982, the Michigan Historical Commission designated it a historic site.

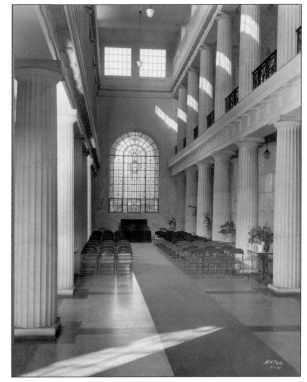

The main hall of the Rose Chapel Mausoleum reinforces the stateliness of the exterior. Two rows of Doric columns, made of white Vermont marble, flank the hall. Visitors' eyes are drawn to the Belgian glass window at the rear. The colored glass resembles stain glass and is valued at more than $250,000.

This photograph depicts the cemetery in its early days. Still visible is the cow gate, a remnant of the land's use as a cow pasture by the Cromie family. The gate was removed as the cemetery gradually adopted more modern landscaping.

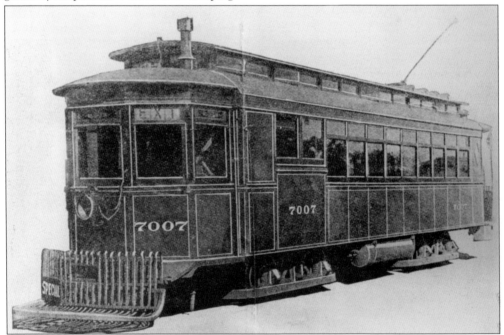

Because transportation of the deceased and mourners by horse-drawn carriage from Detroit was excessively slow, a spur from the DUR line from Woodward Avenue to the cemetery was proposed but never realized. The railroad did provide a coach to take the funeral procession as far as the cemetery entrance, where pallbearers had to continue with the casket on foot. Around 1914, the cemetery added a wagon styled after a prairie schooner to transport the casket from the train into the cemetery grounds. The railroad car would then proceed to Birmingham and circle back to pick up mourners after the ceremony. A potbelly stove on board enabled the bereaved to have a hot meal during the trip back to Detroit.

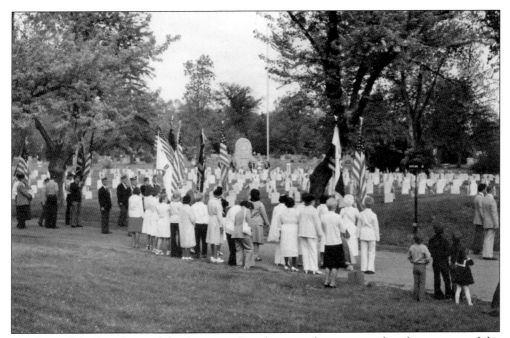

Members of the Daughters of the American Revolution gather to remember the veterans of the Spanish-American War. This section of the cemetery contains the graves of 360 such veterans.

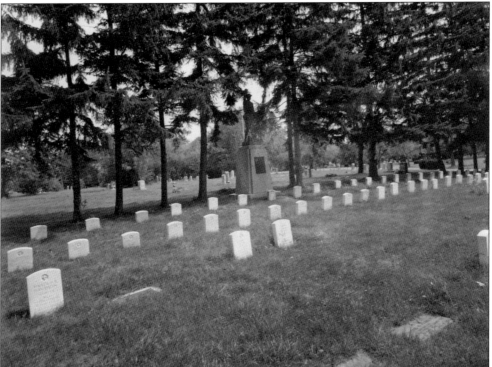

Pictured is the World War I portion of the section reserved for veterans of foreign wars. In the background is a bronze statue of a soldier created by Marshall Fredericks, a famous sculptor whose studio was on Woodward Avenue. The statue was removed in 2002.

This stately burial crypt belongs to the Grinnell family. The most notable of the interred is Ira Leonard Grinnell. His first business was sewing machines, but in the late 19th century he and his brothers, Clayton and Herbert, founded the Grinnell Brothers Music House famous for pianos and organs. Eventually, the business grew to 26 branches in Michigan, Ohio, and Canada. One of Grinnell's achievements was improving the player piano and propelling it into a popular instrument around the world.

A classic car begins its journey from the cemetery grounds as part of the Berkley CruiseFest. The cemetery serves as the staging area for the parade of classic cars in the city's contribution to the Woodward Dream Cruise each August.

ABOUT THE AUTHORS

JAMES JEFFREY TONG has lived in Berkley all of his life. He received a bachelor of arts in history and then a master's in library science from Wayne State University. After spending four years overseas serving in the Air Force, Tong returned to Berkley and married the late Sharon Ellison. He worked for 33 years as a librarian at the Detroit Public Library and now is a part-time librarian at Oakland Community College and the Detroit Athletic Club. He is the proud parent of Emily Vickey. For over 30 years, Tong has served on the Berkley Historical Committee and is currently the vice chair.

SUSAN RICHARDSON, chair of the Berkley Historical Committee, has lived in Berkley for more than 20 years and considers it her second hometown. Richardson has a doctorate of philosophy in English and teaches composition at Macomb Community College, where she also serves as co-chair of the Professional Practices Committee. An avid figure skater, she belongs to the New Edge Figure Skating Club and serves on its board. She is married to Mark Richardson and has two grown children, Emma and Eric.

STEVE BAKER, a resident of Berkley for well over a baker's dozen years, is a director of information technology at DTE Energy. He received his bachelor's and master's degrees in computer science at Oakland University. Formerly the secretary for the Berkley Historical Committee, Baker is currently a member of the Berkley City Council and serves as a liaison to the committee. He is also active in regional transit initiatives, serves on the board of several nonprofits, and with wife Nicole Artanowicz enjoys Berkley's beautiful neighborhoods, great people, and vibrant downtown.

DISCOVER THOUSANDS OF LOCAL HISTORY BOOKS FEATURING MILLIONS OF VINTAGE IMAGES

Arcadia Publishing, the leading local history publisher in the United States, is committed to making history accessible and meaningful through publishing books that celebrate and preserve the heritage of America's people and places.

Find more books like this at
www.arcadiapublishing.com

Search for your hometown history, your old stomping grounds, and even your favorite sports team.